THE HEALING ARTS

THE ARTS PROJECT AT CHELSEA AND WESTMINSTER HOSPITAL

Published in 2019 by **Unicorn**,
an imprint of Unicorn Publishing Group LLP
5 Newburgh Street
London
W1F 7RG

www.unicornpublishing.org

Text © see individual chapters
Images © see pages 164 & 165

CWPLUS Registered Charity No.1169897
Company limited by guarantee in England and Wales No. 10410134 www.cwplus.org.uk

ISBN 978-1-912690-26-8

10 9 8 7 6 5 4 3 2 1

Designed by Tim Epps
Printed in Turkey for Jellyfish Ltd

THE HEALING ARTS

THE ARTS PROJECT
AT CHELSEA AND
WESTMINSTER
HOSPITAL

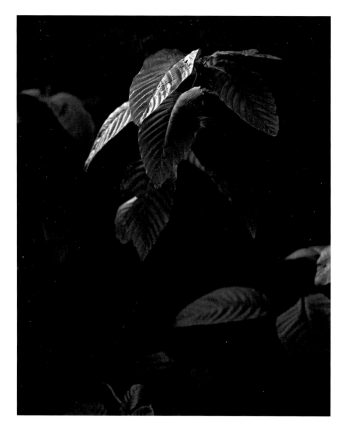

Chloe Dewe Mathews (b. 1982)
Camptotheca Acuminate,
from *A Modern Herbal: Experiments in Botanical Imaging, 2016*
Diptych: C-type prints, wood, glass and dibond
Chelsea and Westminster Hospital

CONTENTS

FOREWORD

Art serves many purposes, often to communicate, to emote, to create a sense of beauty or to motivate; but within the walls of Chelsea and Westminster Hospital it plays another vital role.

Art goes above and beyond, and instead becomes a tool for healing.

Championed by staff, artists and patients alike, the CW+ arts programme is a force to be reckoned with. Unlike so many hospitals, with their stark white walls and sterile interiors, Chelsea and Westminster Hospital is curated as if it were a museum. However, distinct from a museum, the interior walls of the hospital have become the throbbing heart of the local community. The hospital gives access to art to all that come through its doors. Access to art is a strong theme throughout the book, for both the patients and the hundreds of staff that work there. I am delighted that The Fine Art Group are able to support the ambition and creativity that fuels CW+, especially in celebrating the arts programme through this book.

I have been extremely lucky to have been part of Chelsea and Westminster's local community for over twenty-five years. Since the 1990s, the hospital's revolving doors have always been welcoming. Countless hours have been spent in the hospital with young children in tow, and the sense of relief to have that reassurance so close, so accessible, is invaluable. After the birth of three grandchildren within the hospital, and my son having worked there, the hospital has become more personal than clinical.

A hospital can bring forth one's worst fears, but art has this incredible ability to transport the viewer; a painting can change your attitude, bring you joy, reassurance and confidence. The bright colours of the hospital walls have brought my own family so much comfort. Years ago, I remember my eldest daughter, briefly forgetting her fear and wondering aloud how they had managed to get such a monumental Allen Jones into the foyer, the same sculpture could be seen from her room when she gave birth to her daughter last year. These artworks are cemented and entwined into the local communities' lives. While hospitals are often a place of stress, they also play host to some of a family's happiest moments, having an environment as vivid and colourful.

It was only when I was invited to join CW+'s Development Board that my eyes were opened to the depth of the art and design programme and the huge impact it has upon the local community. I hugely respect CW+'s ability to quantify the effect of the programme to enable all data to be shared with other hospitals around the world. It is not often that one can say art changed lives, but what CW+, the contributors to this book and all involved in the arts programme understands, is that healing takes more than medicine.

To be part of the CW+ art and design programme's future is a tremendous

honour, not least because I am fortunate enough to have personally witnessed the positive impact is has. This book is a testament to the people who created the programme and its legacy.

Philip Hoffman
Founder and CEO of The Fine Art Group
The Fine Art Group works with art collectors and investors at every level of market activity across its three core pillars: art advisory, art finance and art investment.

CW+ would like to thank **Philip Hoffman** and **The Fine Art Group** for their continued support and kind sponsorship of this book.

ii INTRODUCTION

When Chelsea and Westminster Hospital opened in 1993, consultant orthopaedic surgeon James Scott and his colleagues created an ambitious and pioneering hospital arts programme. This programme integrated the visual and performing arts into its acute healthcare setting and created one of the best hospital arts collections in the UK. Over the past twenty-six years, the hospital's charity, CW+, has grown, managed and developed this arts programme. Today, we bring daily music, performance and creative activities into the wards, and hold a collection of more than 2,000 works of art from Renaissance oil painting to contemporary digital art. Our programme has also expanded to our sister site at West Middlesex University Hospital and to our community based sexual health clinics.

Alongside commissioned art, we integrate innovative design into our hospitals. We work with architects and designers to create calming, healing environments with soft, adaptable lighting, soundproofing to make wards quieter, and carefully designed spaces that protect patients' privacy. Our art and design programme is based on evidence

Albert Irvin (1922–2015),
Hollywood, 1995, detail
acrylic on canvas, 137 x 685 cm.
Fracture Clinic,
Chelsea and Westminster Hospital

that the environment a patient finds themselves in can contribute significantly to their healing, reduce hospital stays and promote wellbeing. Having access to images of nature has been shown to improve healthcare outcomes, while research shows that distraction is one of the most effective methods to reduce anxiety during painful treatments for children.

The Healing Arts celebrates the legacy of the arts programme founders at Chelsea and Westminster Hospital, demonstrating how their vision allows us to continue to innovate by commissioning ambitious, bold and daring contemporary art and design that has profoundly positive impacts on patients, staff and visitors. This book offers a chance to reflect on our position as a pioneer in arts and healthcare, and to celebrate our unique collection and innovative programme. We also look to the future with excitement surrounding the increasing evidence and recognition – by clinicians and government – that the arts can help us heal, improve our wellbeing and keep us healthy.

Our work is made possible by our generous supporters and partners. The support we receive not only creates opportunities to work with world-class artists and designers, but enables us to build and enhance clinical facilities to create an outstanding healing environment for patients and staff. We invest in the latest health innovations, technology and equipment to deliver exceptional patient care and outcomes.

As we reflect on the last twenty-six years of our arts programme and look to the future, we will continue to support our patients and communities by providing world-leading facilities, innovative environments, ambitious projects, new technologies and creative activities.

For more information about our work, please visit www.cwplus.org.uk.
—Trystan Hawkins, CW+ Arts Director

1 THE FOUNDING OF THE CHELSEA AND WESTMINSTER HOSPITAL ARTS PROJECT

JAMES SCOTT

The story of how the Chelsea and Westminster Hospital Arts Project came to be, like many good stories, combines obsession, exploration and adventure; and has a happy ending.

The immediate environment of a patient has been used as a complement to medical care since ancient Greece. In the fifth century BC, the diagnosis and treatment of all forms of illness involved the interpretation of dreams in large bright open halls called *Aesculapieia* (after the god of medicine, *Aesculapius*), with the aid of light, music, water and paintings. In 1320, the walls of the Sienese hospital, *Ospedale Di Santa Maria Della Scala*, were decorated with frescoes by Simone Martini. William Hogarth, when aged thirty-seven in 1734, visited the treasurer of St Bartholomew's Hospital in London and volunteered to paint scenes of biblical life on the walls of the hospital he had known since childhood, for nothing. The offer was accepted and the result was the spectacular *Pool of Bethesda* and *The Good Samaritan* paintings for the hospital's great hall.

Florence Nightingale in her notes on nursing from 1859 wrote, '*The effect in sickness of beautiful objects, of variety of objects and especially of brilliancy of colour is hardly appreciated. This is no fancy. People say the effect is only on the mind. It is no such thing. The*

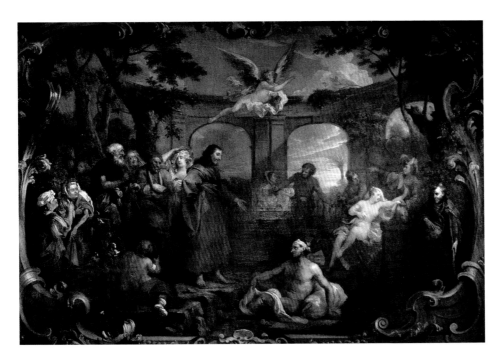

1. William Hogarth (1697–1774), *Christ at the Pool of Bethesda*, 1736. Oil on canvas, 416 x 618 cm. St Bartholomew's Hospital Museum and Archive

effect is on the body too. Little as we know about the way in which we are affected by form, by colour and light we do know this, that they have an actual physical effect.'

Nearer our own time, at St Thomas's Hospital in the 1960s, the architect of the new wing, Eugene Rosenberg, commissioned modern pieces including sculpture by Naum Gabo and paintings by Robyn Denny and Victor Pasmore. The relationship between art and health was further explored in a conference entitled 'Art and the National Health Service', chaired by Sir Patrick Nairne, organised by the King's Fund in 1983.

The new Chelsea and Westminster Hospital was to be built on the site of St Stephen's Hospital, which had in Victorian times combined a hospital (St George's Union Infirmary) and a workhouse (Little Chelsea Workhouse). At the time of its closure in 1988, St Stephen's had twenty-seven wards with 557 beds and a very busy accident and emergency department. I had started a small arts project in the hospital which had two particular successes. There was a long dark central corridor which ran the length of the hospital from the Fulham Road to Gertrude Street, about 100 yards [92m] long. The predominant colour of the walls in the hospital, as generally in National Health Service hospitals, was an unattractive pale green, often called 'hospital green'. I was able, with the help of Sir Hugh Casson, who was the rector of the Royal College of Art and lived near the hospital, and Quentin Blake, who was teaching in the painting department, to have this corridor decorated by students from the Royal College. It took several months but, when finished, completely transformed the mood and feeling within the hospital.

Later we had a scheme to commission a mural for the large front hall. We invited

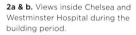
2a & b. Views inside Chelsea and Westminster Hospital during the building period.

submissions from the public and received more than a hundred proposals. A short list was drawn up with the help of a small committee, including Hugh Casson and Sandy Nairne (Sir Patrick's son), who was then Exhibitions Director for the Institute of Contemporary Art. Three were short-listed and examples of their proposals were hung on panels in the front hall for six weeks, with voting boxes in front of each for passers-by to indicate their favourite. The winner was painted by Faye Carey and was an intricate, complicated representation of the history of the site. Many of the details suggested events, personalities and incidents associated with the history of the hospital or its surroundings. The basic plan was arranged within the interior of a drawing room of a house built by the third Earl of Shaftesbury in the eighteenth century on the site of the Little Chelsea workhouse. Among the incidents that were portrayed was an occasion on 3 August 1869 when an inmate of the workhouse, Mrs Hogg, was granted her wish on her one-hundredth birthday of going up in a hot air balloon. Once more the feeling of welcome and wellbeing on entering the front door of the hospital was considerably enhanced by this splendid mural.

I was chairman of the medical staff at St Stephen's Hospital during the long period of consultation before the plans for the new hospital were agreed. As this involved the closure of five hospitals, feelings ran high. What the new hospital was to be called excited particular discussion, before the name Chelsea and Westminster Hospital was accepted. The final staff meeting at the Westminster Hospital – whose origins dated back to 1716 – in 1988 was, therefore, a long and emotional occasion. By the time the last item on the agenda, which was the disposition of the works of art in the hospitals that were to close, had been reached, there were relatively few of

us left in the room. I was given the task of making appropriate representations and suggestions. Over the next few weeks I enlisted the help of two colleagues, Richard Staughton (consultant dermatologist) and Adam Lawrence (consultant in genitourinary medicine), and the Arts Project for the new hospital was founded.

The first issues we addressed were what to do with the works of art that would be displaced, most particularly *The Resurrection* by Veronese, which was in the chapel of the Westminster Hospital. This great Renaissance masterpiece had been painted in about 1587, initially forming part of a series of altar pieces and organ shutters in the church of *St Giacomo Di Murano*, outside Venice. This ensemble had been broken up and dispersed in the second half of the eighteenth century and came to this country in 1780 to be part of the Lonsdale Collection at Lowther Castle in the Lake District. It was subsequently acquired by the central London art dealers, Colnaghi, in 1947. In 1950, it was bought by the chaplain of Westminster Hospital, Canon Christopher Hildyard, for £9,000, with the help of the special trustees of the hospital. It had languished somewhat in the rather dark chapel, which was on the top floor of the old Westminster Hospital, next to the operating theatres, and thus not easily accessible to patients and members of the public. There was much debate within the district management team at the time. Many members did not think it would be appropriate to put the painting in a chapel in the new hospital as this would only appeal to the spiritual needs of a very small minority of patients and visitors. They thought it would be more appropriate to offer it on semi-permanent loan to the National Gallery. It was eventually decided, after much consultation, including with the family of Canon

3. Faye Carey (b. unknown),
St Stephen's Mural, 1984.
Oil on canvas (One of four panels).

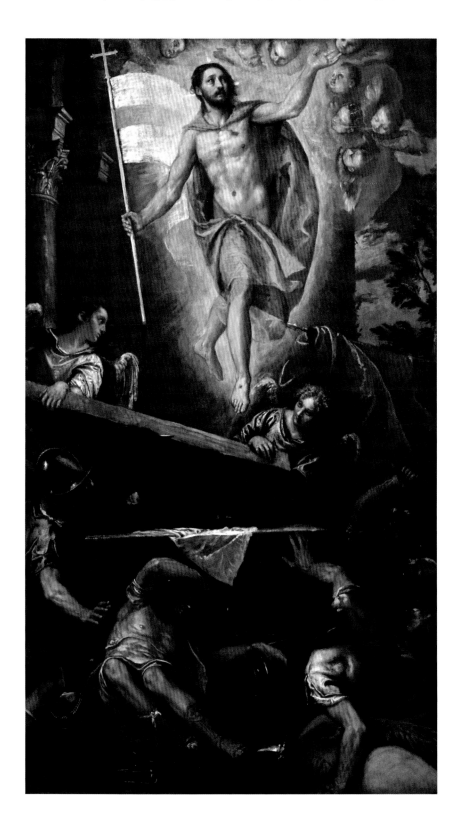

4. Paolo Veronese (1528–88), *The Resurrection of Christ*, 1587. Oil on canvas, 273.4 x 156.2 cm. The Chapel, Chelsea and Westminster Hospital

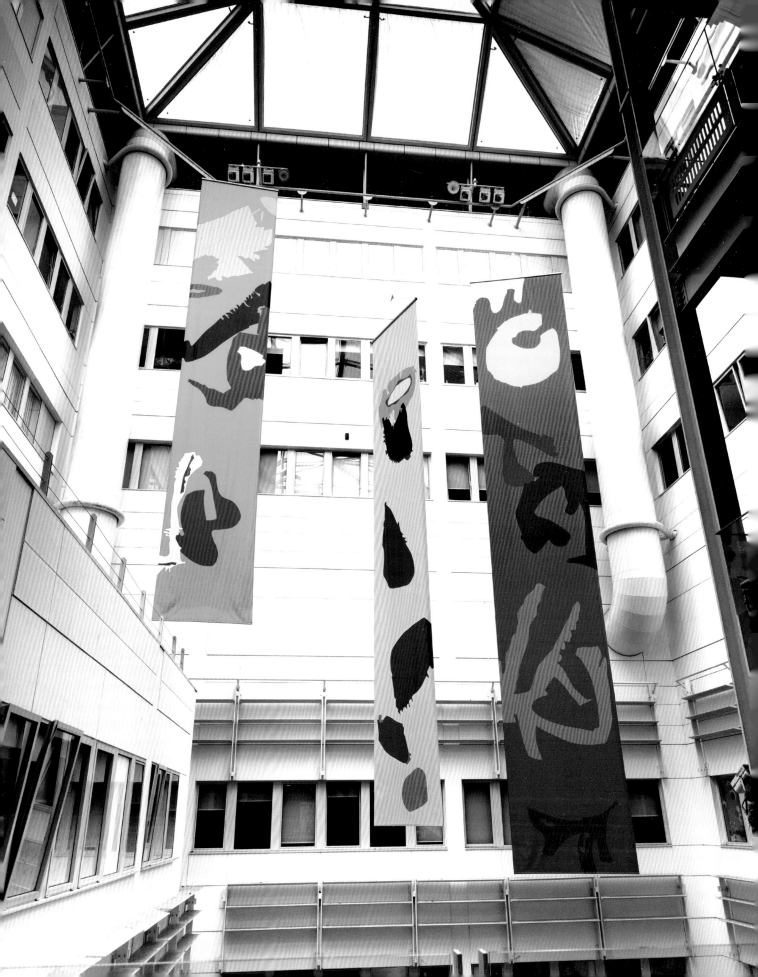

Hildyard, and our encouragement, to put the painting in a chapel which was to be prominently placed in the middle of the first floor of the new hospital.

Room was to be found in the front of the hospital for the handsomely decorated donor boards, which had lined the entrance to the Westminster Hospital, recording previous benefactors. A home was found in a church in Wales for stained glass windows from the chapel in St Mary Abbott's Hospital. Many of the large portraits of previous members of staff were to be placed in appropriate sites and some old, small

5 Opposite. Patrick Heron (1920–99),
Three Banners, 1992-3.
Printed PVC on rigging.
The Atrium,
Chelsea and Westminster Hospital

6. Allen Jones (b. 1937),
Acrobat, 1993.
Painted corten steel.
The Atrium,
Chelsea and Westminster Hospital.

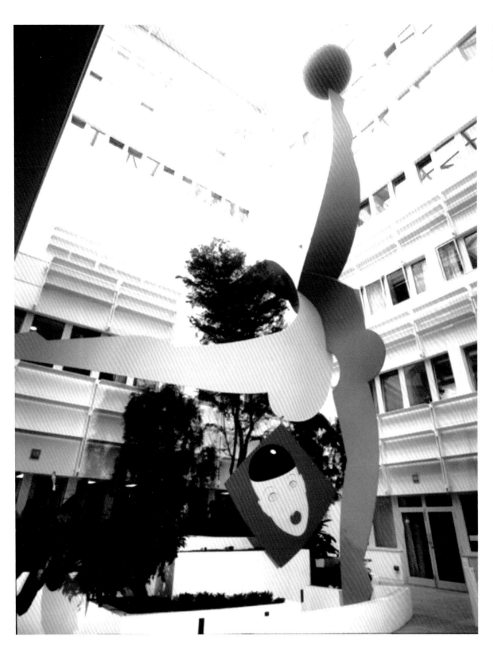

neglected prints and photographs were disposed of.

The next issue was which works could be commissioned for the wonderful spaces beneath the plain roof of the new building. This was thought to be largest naturally ventilated atrial space in the world at the time. We decided that large bold statements of colour were required. Often, before going home at the end of a working day at the Westminster Hospital, I would visit the Tate Gallery for some quiet contemplation as offered, for instance, by the Rothko Room. One evening, in early 1989, the Tate shop was closed as they were installing a series of eight small silk hangings by Patrick Heron. I knew that Patrick had a flat near the hospital, as well as living primarily in Zennor near St Ives. I had visited him in Cornwall for lunch a few weeks earlier. Accordingly, he and I arranged to meet on the site of the new hospital and, a few weeks later, we stood wearing hard hats on the fifth floor, towards the back of the hospital, overlooking the area that would become one of the atria. I suggested to him that he might design three large banners for us, of different sizes. He thought this was an extremely bad idea and we went home disappointed. However, I bullied him endlessly and he finally succumbed, and one Saturday morning, through the post, I received three small designs of gouache on cardboard involving wonderfully characteristic vibrant colours. The commission was not finally formalised until November 1992.

Habotai Japanese silk was chosen and 70 metres were required. Patrick chose this particular silk for its translucency, vibrancy, colour and light weight. The banners were reinforced at the top by cotton voile and silk in quadruple thickness. They were hand sewn in 1-metre sections by Kathy Merrow Smith and installed twelve months later, incorporating ingenious trapezes designed by Patrick's daughter and son-in-law, who are architects. When installed, they would swing gently around in the atrium, and as far as we were aware, no similar pieces of large silk free-moving decorative art existed in a public place in the world.

Once or twice I caught Patrick late in the evening standing in front of them in silent admiration. They eventually faded and were replaced in November 2006, very satisfactorily using fibre glass PVC.

Part of the appeal of initially approaching Patrick Heron was the fact that he had a flat nearby and therefore, when fund-raising, could be called a local resident. The same was true of renowned British pop artist Allen Jones. I knew that Allen had recently made one or two large steel sculptures of dancers and suggested something similar for another atrium. He was anxious to accept the proposal and prepared many drawings. He had just acquired a fax machine, which allowed him to send faxes in colour. Allen was extremely pleased with this new toy and sent me a series of suggestions involving many different coloured components of the sculpture that was to be called *The Acrobat*.

It was eventually installed in 1992 following a successful application for funding to the Foundation for Sport and the Arts, and an extraordinarily generous donation from a patient who had sustained a very complicated fracture of his tibia when he was knocked down while jogging in Hyde Park.

When it was completed and installed Allen, with characteristic generosity, made ten small wooden maquettes as gifts to the sponsors and those who had helped with

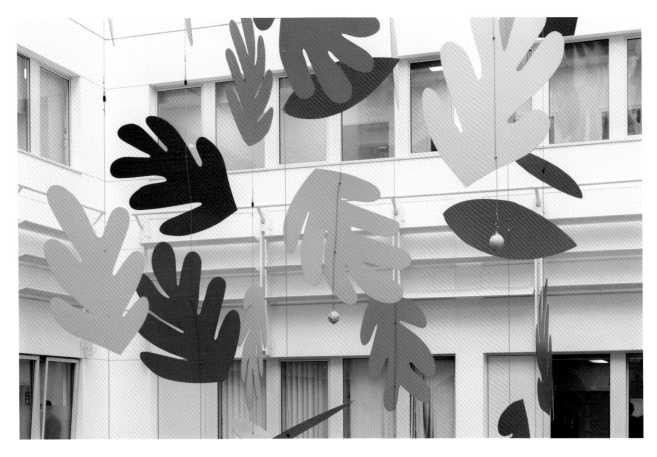

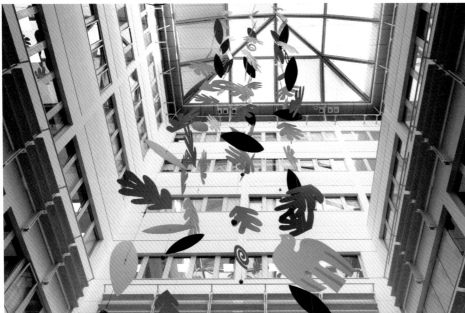

7a & b. Sian Tucker (b. 1958),
Falling Leaves, 1993.
Mixed media.
The Academic Atrium,
Chelsea and Westminster Hospital

8. Above. Albert Irvin (1922–2015),
Hollywood, 1995.
Acrylic on canvas, 137 x 685 cm.
Fracture Clinic,
Chelsea and
Westminster Hospital

the realisation of the sculpture. Leslie Waddington, whose gallery acted as an agent for both Patrick and Allen, was keen to give us a present in recognition of these two commissions and, after some discussion, he very kindly gave us a wonderful large print of a palm tree by Howard Hodgkin.

Among other early influential visitors to the building site were Roger de Grey, Richard Attenborough and Peter Palumbo. Roger would drive past the hospital in his bright green Citroën *Dyane* on his way from the Royal Academy, of which he was president, to his home in Meopham in North Kent. He felt particularly strongly about two aspects. First, that anything that could be called 'community art' – by which he meant any work of art that you could walk past without it evoking a response of some sort – should be avoided. Secondly, he encouraged works of art for the atria that would move. He was pleased with the idea of the silk banners but also pleased when we were able to commission Sian Tucker to make *Falling Leaves.* This piece was to be 29 metres high and to be made of foamex panels, comprising ninety individual elements, with rigging and mechanisms to allow movement in the rising currents of air in the atrium.

Sadly, some years later, Roger died in the intensive care unit in the hospital without being able to see either *Falling Leaves* or Patrick's banners.

Richard Attenborough was an old friend of St Stephen's Hospital due to his

connection with Chelsea Football Club, of which he was a director. I had some responsibilities for the orthopaedic aspects of the team when I was appointed to the staff of the hospital in 1977. He had an extensive knowledge (and collection) of twentieth-century British paintings, particularly the works of Christopher Nevinson. He also had a particular interest in the relationship between the arts and health, having chaired a committee of enquiry into the closely associated issue of the involvement of disabled people in the arts. This committee had been set up by the Carnegie Trust in 1982 and the report was published three years later. He and his committee made very extensive recommendations, particularly about access to all forms of creative activities for disabled people and how this could be achieved locally and nationally. His report was designed to chart the way ahead. He concluded: 'It lies within our power to transform the lives of disabled people and to enrich the world of art itself by their greater involvement. Failure to act diminishes us all.'

Richard was also critical of the ways the arts were used in the NHS. 'The present arrangements are far too haphazard to enable their potential to be realised.' We would discuss these matters at length when he drove me, in his green Rolls Royce, to and from away matches on a Saturday afternoon.

Following the publication of the Attenborough Report, it was felt that a national organisation should be formed to advise health authorities about the best use of all aspects of the arts. 'Arts for Health' was established at Manchester Polytechnic and Peter Senior, who had been a member of Richard's original committee, became its first director. He visited us several times at the outset to help and advise, as also did Dr Hugh Baron, who had taught me at medical school and who had done so much for arts projects at St Mary's Paddington, and Hammersmith Hospital.

9. Maggi Hambling (b. 1945), *Sunrises*, 1992. Watercolour on paper, each painting 48 x 60.5 cm. Chelsea and Westminster Hospital

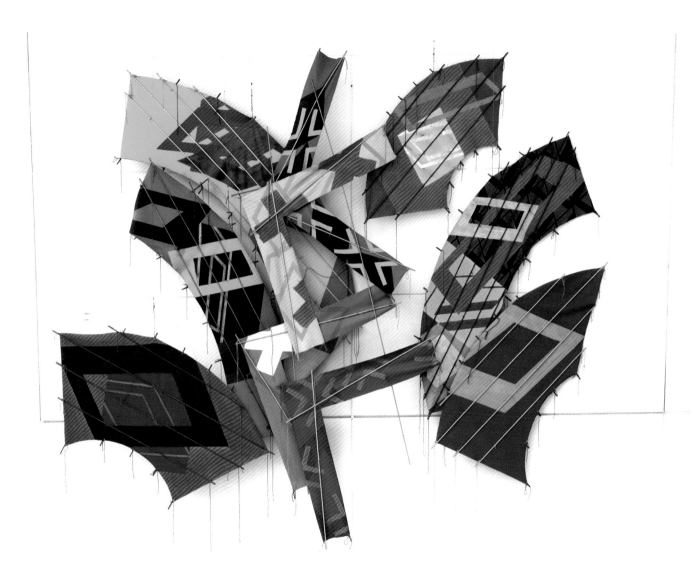

By the time the hospital opened in 1993 after a rather tentative start (the future of the Veronese established and major commissions for three of the *atria* completed), the project gathered steam and we were on our way. We were quietly confident that having been able to get these major works in place, the rest would naturally follow.

We decided we needed an arts director to be responsible for the daily running of the project and Susan Loppert, an art historian and critic with extensive experience in both the commercial and public sectors, was appointed, initially for three days a week. She started three months after the hospital was opened and brought great energy, dedication and insight to all aspects of the project. She was later joined by an assistant, and a part-time manager with specific responsibilities for performances.

We found that we needed two committees. First, a small fund-raising committee, which met infrequently and was made up of people with an interest in public art and knowledge of potential sponsors from industry and arts bodies, such as orchestras and art schools. We were lucky enough to persuade Peter Palumbo, who was chairman of the Arts Council, to chair this committee for us. A second committee, which was much larger, would meet frequently. In this group we tried to include representatives

from as many areas of hospital life as possible, and works of art submitted for purchase were considered. It is clearly central to the project (and still is today) that the paintings or sculptures be understood to be owned by a charitable body on behalf of the Foundation Trust and of everyone who visits or works in the hospital – thus outside the NHS. At that time, about 500,000 people passed through the hospital annually and the works would be seen by more people than those on the walls of most public art galleries. We were quickly able to include the help of nurses and doctors from many different specialities, as well as physiotherapists, porters and patients. It is, of course, difficult to select works of art by committee but we found it relatively easy to establish some general principles: it is easier to choose abstract paintings than figurative paintings; we were to bear in mind Roger de Grey's advice of avoiding 'community art'; the colours brown and grey were unpopular.

Shortly after it was installed, the Veronese was extensively cleaned and restored, revealing an unexpected dog on the right-hand side towards the bottom of the painting. We were then very happy to lend it to an exhibition of *El Greco – Italy and the Italian Influence in Athens*. The painting had not left this country for more than 200 years and it was accompanied to Athens by Susan Loppert and Jeremy Booth, a consultant in accident and emergency medicine and a member of the committee.

11. Jonathan Delafield Cook (b. 1965), *Jos the Rhino*, 1996. Charcoal on paper, 309 x 168 cm. Chelsea and Westminster Hospital

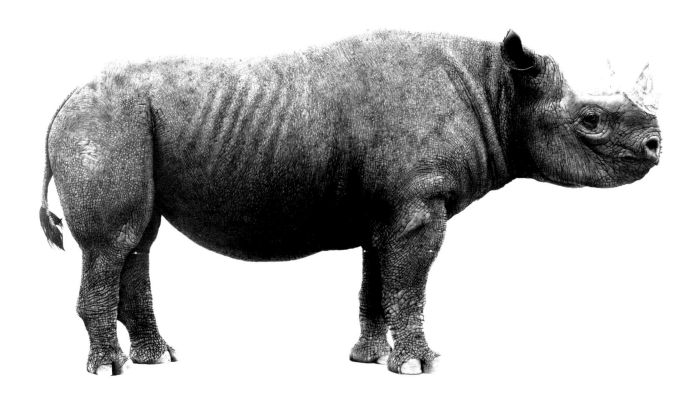

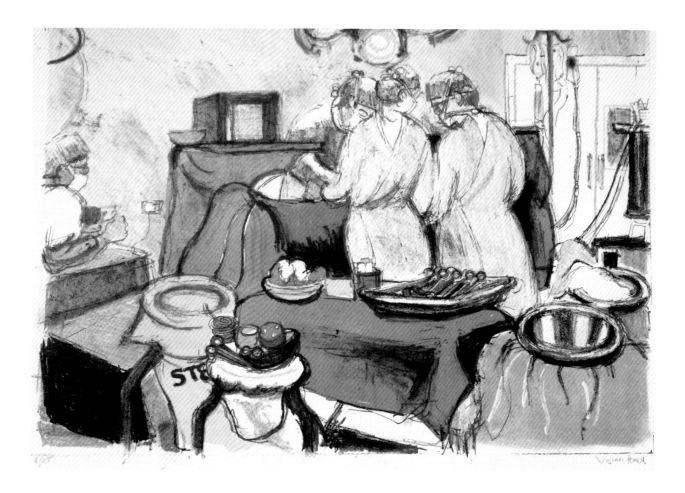

12. Virginia Powell (b. 1939),
Concentration, 1995.
Lithograph, 29 x 39 cm.
Operating Theatre,
Chelsea and
Westminster Hospital

The issue now was how to decorate the the multi-faith sanctuary. We decided to
have a competition and various artists and students from the Royal College of Art
and City & Guilds Art School submitted proposals. We sought senior guidance from
a small committee, including William Packer (*Financial Times*), Deanna Petherbridge
(the Wellcome Institute), Bryan Robertson (previously of the Whitechapel Gallery)
and Marina Vaizey (the *Sunday Times*). After some deliberation, three artists were short
listed: Maggi Hambling, Mali Morris and Shirazeh Houshiary. Maggi Hambling's
series of ten watercolours depicting sunrises over the Orwell River in Essex on three
consecutive mornings, was finally chosen, and installed in 1994. I particularly liked a
circular grey disc design submitted by Shirazeh Houshiary, with large regular thumb
print-like marks, which would occupy the entire end wall. Somewhat later, Maggi
made three charcoal portrait drawings of the founders, myself, Richard and Adam.

We continued to be helped regularly by both artists and friends. Bert Irvin lived
near us in South London. There were several of his wonderfully vibrant large abstract
paintings in hospitals around the country and I was anxious to acquire one for the
fracture clinic. He had the excellent idea of putting eight small preparatory sketches on

the proposed walls with a questionnaire inviting opinions as to which was preferred. After four weeks and more than a hundred votes, *Hollywood* was declared the winner. Bert liked to call his pieces, which were in public collections, after neighbouring roads, Hollywood Road being opposite the hospital. He was touched that one of the preparatory sketches, despite security fittings, was stolen. A group of us visited his studio in Stepney while it was being prepared. The final canvas was about 550 cm long. Soon after it was installed, a patient in a wheelchair told a member of staff, 'It makes me feel as if I am on ecstasy.'

13. Sandra Blow (1925–2006), (left–right) *Through and Beyond, Side Effect, Inside Story, Split Second*, 1993-94. Silkscreen prints, each 119 x 119 cm. The Atrium, Chelsea and Westminster Hospital

A few years later Bert became a patient when he fell and broke his wrist. I asked him to decorate his fibreglass cast after it was removed, which he did – in a riot of reds, yellows and blues. We proudly displayed this for some time in a Perspex box on the wall in the clinic.

For the first few years we were extremely lucky to have an informal and unofficial artist in residence. Virginia Powell is predominately a printmaker. She is a neighbour of ours in South London and had been taught at Chelsea College of Art. Initially, Virginia did several studies of empty wards as the Westminster Hospital was closed. In the new hospital she would sit unobtrusively in various corners around the

hospital. She did many representations of operations, mainly either general surgical or orthopaedic. She was extremely prolific, creating several hundred works, and had two very successful exhibitions in the hospital in 1994 and 1997, as well as contributing to an exhibition at the Wellcome Institute.

During the summer of 1995 I was contacted by the Royal College of Art. One of their students, Jonathan Delafield Cook, had included in his diploma show a life-size charcoal drawing of an eastern black rhinoceros called Rosie, who was the first of her kind to have been reared at London Zoo. The drawing had been bought by Mrs Lindsay as a gift for her son, James, a patron of the charity Tusk. The charity's principal aim was to help this endangered species, of which there remained only 470 in the wild. James was unable to accommodate the large drawing at that time and asked if we could look after *Rosie* for a while. We were, of course, delighted to do so and

14. Mary Fedden (1915–2012), *Fruit and African Violets on a Red and Pink Ground*, 2000. Oil on board, 61 x 71.5 cm. Chelsea and Westminster Hospital

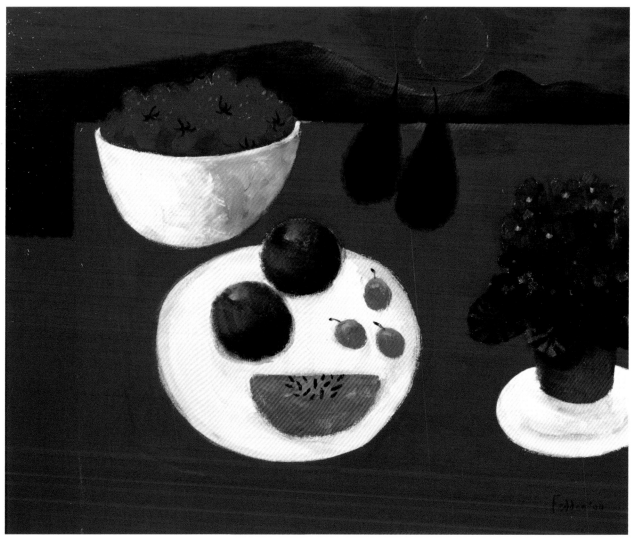

placed her prominently towards the front of the hospital. *Rosie* was immensely popular and, when James was able to take her back, public pressure urged us to commission Jonathan to draw her partner, *Jos*, who weighs a ton and was born in captivity in Czechoslovakia in 1989. He took *Rosie's* place about twelve months later.

I had an idea, which was never realised, to commission artists who were particularly supportive of the project, to decorate kites that we would hang under the roof of the hospital, with long tails that would hang down and flap around colourfully. I imagined contributions from Patrick Heron, Sean Scully, Joe Tilson, Sandra Blow and Mary Fedden, among others. It proved extremely difficult to obtain advice about the appropriate material for the kites and, if it was to be canvas, how the material should be treated, particularly bearing in mind the sunlight shining through the transparent roof. I now realise that they could have been made of fibreglass. However, one evening I was having dinner with the choreographer, Siobhan Davies, who was advising us about dance projects for the stage, and she suggested that we might be able to obtain a large kite-based piece designed by Richard Smith. It had just been the basis of a set for a ballet designed by the choreographer, Richard Alston, for Ballet Rambert. Accordingly, the next day I phoned the office of Ballet Rambert and was told that I could certainly borrow the piece, which was in storage in Birmingham. I asked if I should get the permission of Mr Smith and was told it would be easier to present him with a *fait accompli*. Not quite knowing what to do, I rang Allen Jones for advice and he gave me Richard Smith's phone number in New York. When I spoke to him he advised against that piece and asked if he could come the following week to visit the hospital as he would be in London. When he came, he proposed lending us a piece called *Seraphim*, which was in storage in New York. This fabulous piece was freighted from New York in 1997 and has been cleaned, dismantled and re-installed on two occasions.

In 1996, one of my day-case operating lists was cancelled and I took the opportunity of going to Flowers East Gallery, where there was an exhibition of very large mono prints by Richard Smith. I was able to buy four (three for the hospital, which hang outside the operating theatres, and one to go in our kitchen at home).

Sandra Blow had become a friend many years ago. When she moved to St Ives in 1997, we visited her in the enormous studio that had been Ben Nicholson's. From her upstairs window we could see Porthmeor beach and the lighthouse that features so prominently in the paintings of Alfred Wallis and from which Virginia Woolf's novel took its name. We were to acquire four large screen prints by Sandra and she subsequently gave us two collages.

Some years later a distinguished local actor wrote to us after he had been admitted to the hospital with a heart attack, saying, 'Having been given a very nice painkiller, I was being wheeled along the corridor when I noticed we were passing a splendid series of Sandra Blow prints, cheerful and lively and dancing on the walls, which put me in a splendid humour.'

Mary Fedden was an extremely active and prominent early patron and supporter of the project, and we visited her regularly in the studio that she had shared with her painter husband Julian Trevelyan by the river in Chiswick. Julian had died in 1988. When I was a junior doctor, I bought a small watercolour by Mary of a garden in

15. Edward Bawden (1903–89),
Inns and Railways
(for the P & O line), 1949–51.
Oil on 11 panels, 176 x 539 cm.
Jennings Fine Art and Liss Llewellyn

Florence and it had accompanied me to various hospitals during my early surgical training. Many of Mary and Julian's works can be seen in various hospitals, the best example being a large mural in Charing Cross Hospital, dating from 1953. We were able to acquire a large still life of Mary's *Fruit and African Violets on a Red and Pink Ground* and she generously gave us several works by her and Julian.

Edward Bawden taught at City & Guilds Art School during the 1970s and among his pupils was my wife, Kate, who predominantly, then, did calligraphy. She did some lettering for Edward and we had visited him in Saffron Walden, so I was particularly pleased when Peter Nahum of the Leicester Gallery offered to lend us a group of eleven large panels called *Inns and Railways*. Edward had painted these between 1949 and 1951, for the SS *Oronsay* of the P&O Line. This liner took émigrés between England and Australia and the panels were on the walls of the first class lounge. Edward also designed menu covers and curtains for the liner. *Inns and Railways* (Fig. 15) fitted perfectly in the front of the hospital, on the right as you entered, and we were able to keep the installation for about three years. We made a bid for lottery funding to buy the panels and several other works but this was, unfortunately, turned down.

We had, however, been able to acquire an enormous mural by Edward called *Fantasy on Islamic Architecture*, which fills the lower half of the last atrium, on the left. This was commissioned by BP for the restaurant when they moved into their new corporate headquarters in Britannia House in the City of London in 1966. They moved into new premises in 1996 and, with the help of Peyton Skipwith, Edward's dealer and, later, his chronicler, we were able to install them as a semi-permanent loan in July 1996.

I used to visit Prunella Clough who, for many years, lived near the hospital. At the opening of a retrospective exhibition of her work at the Camden Arts Centre in September 1996, despite competition from the Tate Gallery, I was able to buy *Small Stack* (JS fig. 18) for the hospital, at a generously reduced price. Prunella was always very retiring and reclusive, disliking any attention being paid to her. She became more so with the passage of time and did not like the attention she received when she won the Jerwood Prize in 1999. With very characteristic generosity, she gave the Arts Project a significant slice of the prize money. Prunella died in the hospital on Boxing Day of that year.

Each atrium has a shelf on either the ground or first floor where sculptures can be shown. I was anxious to have a piece by Kenneth Armitage, whose work I had first noticed in the mid-sixties. I was then a medical student at the Middlesex Hospital and lived with four flatmates in a large basement flat off the Fulham Road, very near to St Stephen's Hospital. There were museum charges in those days but the Tate Gallery was free on Sundays when we would often visit it and have lunch in a pub nearby. I remember wandering around an open-air sculpture exhibition across the river in Battersea Park on one such morning and I particularly liked a rather strange piece which measured about 180 x 60 cm. It had two funnels pointing out from the upper aspect. It was called *Pandarus*. The bronze was flat and slightly textured and there were

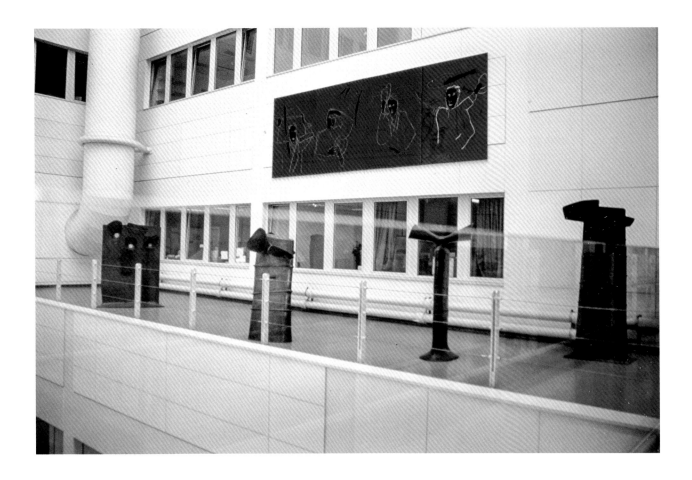

16. Kenneth Armitage (1916–2002), *Pandarus*, 1963. Bronze

narrow transverse ridges. Although basically abstract, it seemed to have figurative connotations. One imagined noises or voices coming from the trumpet-like funnels. I thought vaguely about this sculpture over the years and I read a little about Armitage and discovered that he had represented the United Kingdom at the Venice Biennales in 1952 and 1958. I learned that *Pandarus* was a soldier who, in Homer's *Iliad*, fights on the side of Troy in the Trojan Wars, and was used by Chaucer as a go-between in Troilus's affair with Cressida. I also discovered that Kenneth Armitage still worked from a studio in Olympia. I engineered a meeting through a mutual friend. Kenneth and I became friends and I visited him several times in his studio. In 1996, he had a large retrospective exhibition at the Yorkshire Sculpture Park, opened by Lord Gowrie, that was a tremendous success. The exhibition was due to close in the autumn but was extended until April 1997. When the time came for the exhibition to be taken down and the pieces to be returned to the collectors and galleries from whence they had come, I asked Kenneth if we could borrow a piece for the hospital. 'How many would you like?' he replied. So, by wonderful good fortune, we were able to borrow four pieces. We had them for about two years during which time I was able to visit the *Pandarus* piece, which I had seen in the park thirty years before, each morning when I

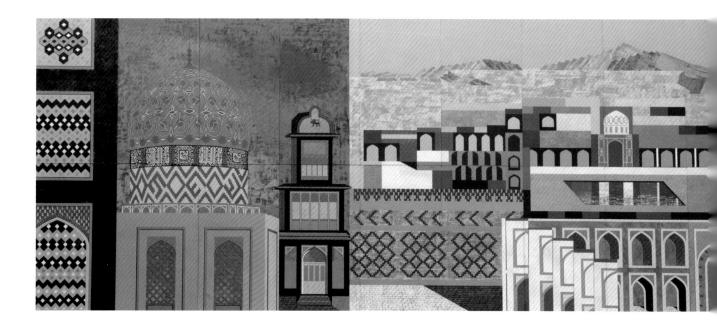

17. Edward Bawden (1903-89),
Fantasy on Islamic Architecture,
1966.
Oil on panel, diptych,
each panel 412 x 914 cm.
Chelsea and Westminster Hospital

arrived in the hospital. Kenneth was anxious that we should buy it and offered it to us at a much reduced price but I was unable to raise the money. Eventually it was returned with the others to a commercial gallery and sold for an extremely handsome price.

The sculpture of Nigel Hall seemed ideal for one of the atria shelves. After visiting his studio in South London in 1996, he lent us three wonderful pieces, *Scolio II* and *IV* and *Big Blink*. A generous benefactor bought *Scolio IV* for us in 1999. We were subsequently extremely happy to lend it to an exhibition of Nigel's work at the Yorkshire Sculpture Park in 2004.

Eduardo Paolozzi lived just off the Fulham Road. I would occasionally see him searching for interesting *objets trouvés* through the litter bins beside the road. Early on, he gave us a series of ten screen prints. I was very keen to have him design a collection box for us. He had made a similar piece for the Royal Academy which I much admired. After many months of cajoling, he asked me one day what I wanted to be written on the front of it and I replied, just 'The Healing Arts'. He invited me to his foundry in Putney the following Sunday, and to bring along any children that I had. We had two at the time and with them we had a very happy morning with Eduardo. We wrote the words 'The Healing Arts' and a few months later, in October 1997, the fabulous collection box was delivered and it has been delivering generous donations ever since. Eduardo would not accept a fee and we were only charged for the cost of the casting.

On one occasion, the box was damaged by a patient in an agitated mental state. He came a few days later to apologise and to explain his predicament, and to offer his help to the project.

At the time that I was considering retiring, Eduardo and I met in the hospital and he asked me to visit his studio on a weekly basis to draw with him. Unfortunately he

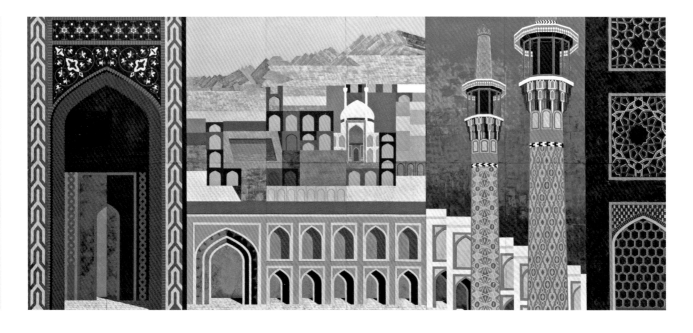

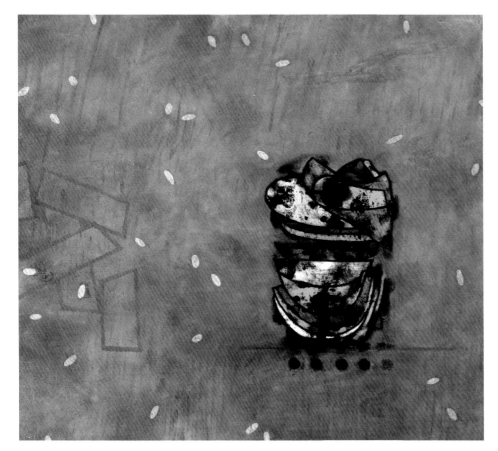

18. Prunella Clough (1919–99),
Small Stack, 1996.
Oil on canvas,
122 x 125 cm.
Chelsea and Westminster Hospital

19. Nigel Hall (b. 1943), *Scolio IV*, 1994. Wood, 152 x 296 x 84 cm. Floor-based sculpture on left of photograph installed as part of Hall's 2008 retrospective at Yorkshire Sculpture Park. Sculpture donated to Chelsea and Westminster Hospital by the late Tom Bendhem. Photo: Jonty Wilde/Yorkshire Sculpture Park

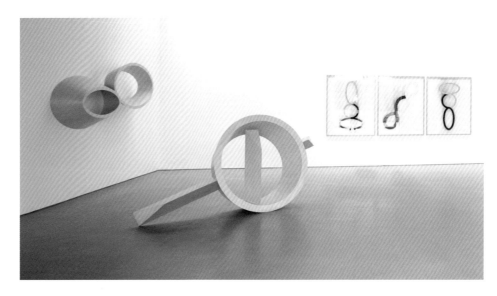

20. Eduardo Paolozzi (1924–2005), *The Healing Arts*, 1997. Bronze, 188 cm (h). Main Reception, Chelsea and Westminster Hospital

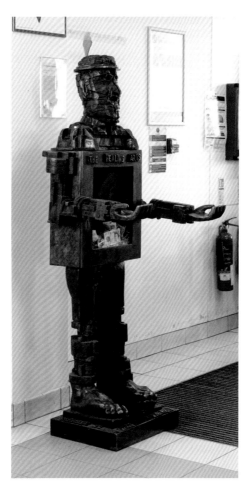

collapsed before this happy plan could be realised. He was in the intensive care unit for some time. He made a partial recovery and eventually was moved to a home in Notting Hill, where I visited him on various occasions before he died.

Also in 1997, I persuaded the managing director of an implant company (Chris Hunt of Stratec), which made many of the prostheses that we used, to sponsor a sculpture on the theme of movement or joint replacement. This was to be sited towards the front on the first floor, between the top of the escalators. We invited submissions and received twenty proposals. Chris, Susan and I were helped in the selection process by Ann Elliott from Sculpture at Goodward, and we chose a lovely and lively piece by Wendy Taylor called *Dancer*. Wendy was maybe best known then for a sundial called *Timepiece* beside Tower Bridge. *Dancer* has two basic balanced wing-shaped segments joined in the middle with jointed or pivotal movement. It is

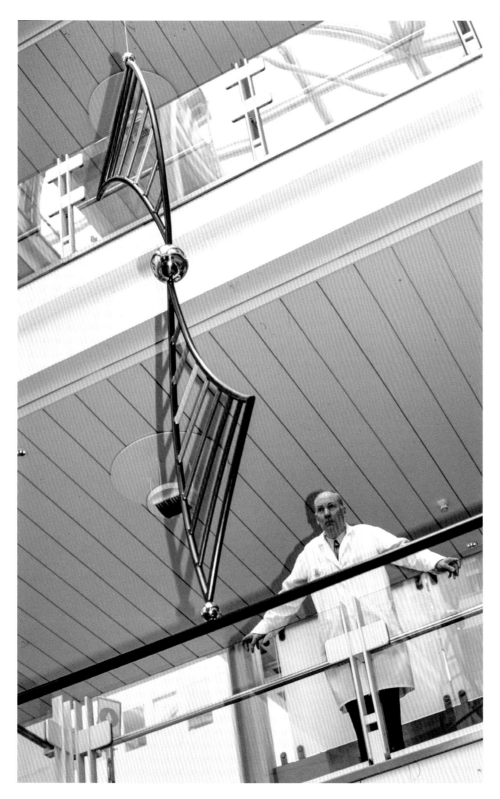

21. Wendy Taylor (b. 1945),
Dancer, 1999.
Painted aluminium
and stainless steel.
First Floor Atrium,
Chelsea and Westminster Hospital
James Scott in background

22. William Pye (b. 1938),
Water Cube, 1996.
Stainless steel and granite.

30.5 cm high and made of painted aluminium and steel.

We visited Wendy's studio in East London to admire *Dancer* and to discuss colour. It was unveiled in March 1999 by Chris Smith, who was Secretary of State for Culture, Media and Sport, and also a patron of the Arts Project.

The prime site for a sculpture remained the area between the elevators towards the front on the ground floor. We made appropriate representations to the Henry Moore Trust, on whose behalf Tim Llewellyn and Alan Bowness visited with other representatives from the Tate Gallery. Sadly, however, despite lengthy negotiations, it did not prove possible to identify a sculpture to put there, or to raise the necessary funding.

I had admired various water pieces that William Pye had made, including a large one in Gatwick Airport. We visited his studio in Wandsworth several times. I decided to try to put a water sculpture in the site between the elevators but, although the healing powers of water as streams, channels and fountains, had been extensively used, there remained particular problems in relation to the transmission of bacteria from droplets of water in such conditions. We bought *Water Cube* from the Royal Academy Summer Exhibition in 1996. It fitted perfectly in this site and received clearance from the consultant bacteriologist, who was extremely keen to support the project.

There were recurrent minor problems with the motor that drove the plate on top of the sculpture, over which the water ran, and as time passed the bacteriological aspects became increasingly complicated. With sadness, the sculpture was eventually

23. David Gaggini (b. unknown), *Itai Doshin*, 1997, painted fibreglass

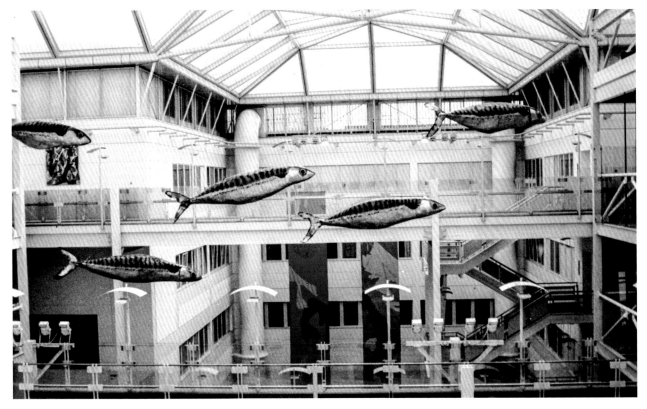

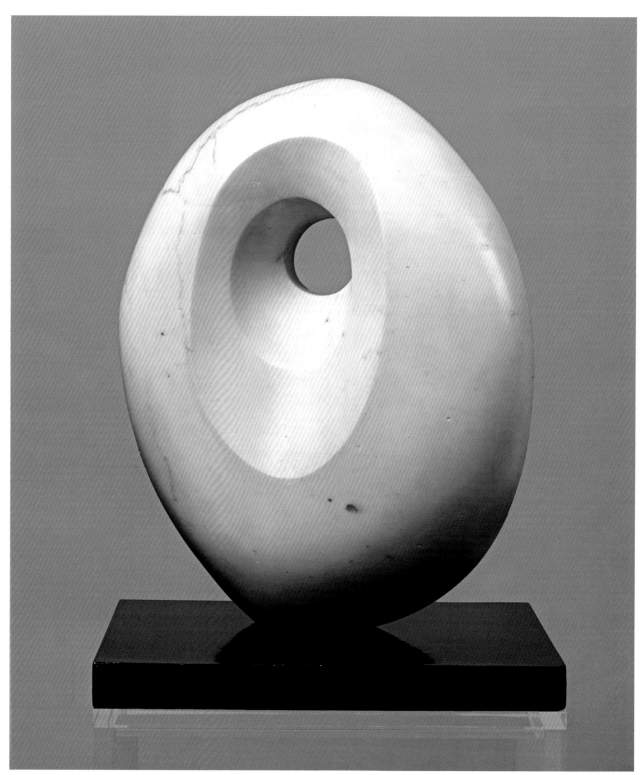

sold. It seems, in fact, that the *Legionella* bacterium is not the main cause for anxiety as it requires a temperature of about 35 degrees centigrade to survive, which is much warmer than the water in sculptures. The much more common bacteria in the aerosol spray generated by the water are the bigger problem.

Five tall, thin, colourful pieces called *Totems* by Rachel Owen were installed on a shelf towards the back of the hospital in November 1997 and, a few months later, a further mysterious totem was added. The addition was not noticed for several weeks. Rachel was pleased and proud and thought it fitted perfectly. We discovered the mysterious extra sculpture was the work of a junior doctor who had made it at home and smuggled it in to the hospital one evening. It remained as part of the assembly.

Continuing our association with the City & Guilds Art School, we were fortunate to be able to borrow two wonderful groups of Carrara marble sculptures by Michael Kenny, who took over as director after Roger de Grey. These pieces were called *Comedy and Memoria*. Sadly, Michael also died in the hospital, a few days after Prunella Clough.

Susan introduced us to the vibrant and colourful sculptures of Edward Dutkiewicz, through Flowers East Gallery. Edward had multiple sclerosis, which he bore extremely cheerfully, from a colourfully painted wheelchair. There were several small steel sculptures in his piece called *Dancers, Snakes & Rusty Men*, which we put on a shelf. They were extremely successful and two were bought for the project by Susan Hampshire, and Edward also donated one or two himself. Susan was able to commission two further larger pieces called *Silver Twins*, which were the largest sculptures Edward made. They were installed in April 2002 to great acclaim.

In the absence of kites, we were extremely pleased when we were approached by David Gaggini to install a piece called *Itai Doshin* high under the roof of the hospital. This piece involved five sculptures of mackerel each about 460 cm long and made of bamboo, chicken wire and ethafoam. They had hung in a shopping centre in Willesden and David asked Susan about installing them. They were tremendously popular. The foam began to deteriorate after a while and were eventually donated on to a school.

We were always seeking ways to involve art students in the project and in 1997 approached Teresa Gleadhowe, who was the course leader in visual arts administration at the Royal College of Art, to ask if she could suggest a graduate curatorial student to put together an exhibition of student work dealing with aspects of art and health for us. We formed a small group to oversee this process, including Wendy Baron (Government Art College Fund), Deanna Jones (Wellcome Institute), Katherine Kinley (Tate Gallery) and Angela Weight (Imperial War Museum). They met regularly at the hospital while the exhibition was being planned. Tamsin Dillon was proposed as curator and she invited new site-specific contributions from eight artists. Funds were raised and each artist got a fee and reimbursement for the costs of making their pieces.

Martin Creed made a neon sign in a Perspex box reading *Don't Worry*. It was the first of many different pieces with this name, of different shapes, sizes and colours, such as the one in the exhibition at the Tate Gallery when he won the Turner Prize in 2001. *Don't Worry* was very popular and became the title of the exhibition. We placed it on the wall in the café. Brian Cyril Griffiths made mysterious guardian figures of

24. Barbara Hepworth (1903-75), *Pierced Form (Santorini) Opus 337*, 1963. Marble, 43 cm. © Bowness

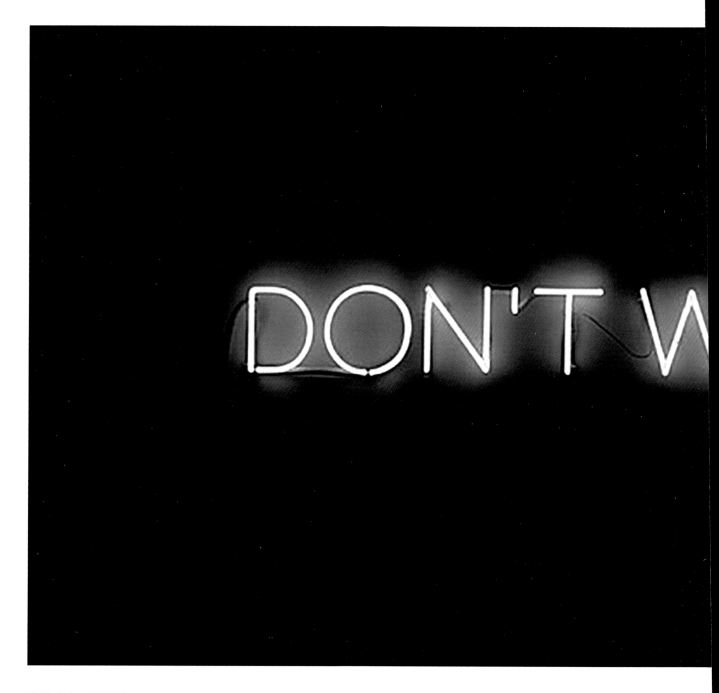

25. Martin Creed (b. 1968),
Work No. 230, DON'T WORRY, 2000.
White neon, 15 x 144 x 4.5 cm.
© Martin Creed

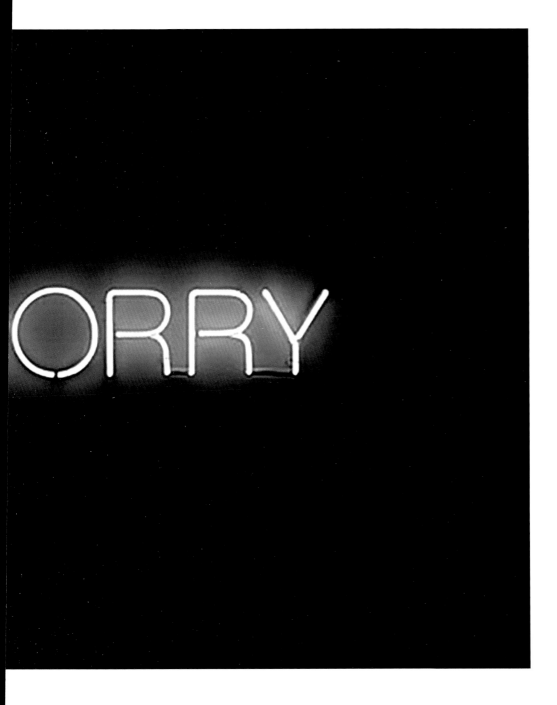

paper and bandages that were 200 cm high, and a nurse with x-ray eyes. Other artists include Ori Gersht, Parminder Kaur, Simon Lewandowski, Elizabeth LeMoine, Kaffe Matthews and David Shrigley. The whole project was a great success.

The exhibition ran from February until June 2000, with associated workshops and visits to schools. It was widely and favourably reviewed: 'Presenting patients' experience of hospital may be a bit obvious but it worked surprisingly well'; 'Some of the works have a humour that makes the whole show so much stronger.' Many of the commissioned pieces happily remain in the hospital. Tamsin has, subsequently, run a programme of art for the London Underground for many years.

Barbara Hepworth, as a sculptor, is of particular interest to an orthopaedic surgeon for her association with the surgeon Norman Capener. They first became friends when Capener treated one of her children for osteomyelitis of the femur. Much later he invited her to his operating theatre in Exeter and she created many powerful drawings of surgeons operating, some of which are owned by the Royal College of Surgeons. Capener himself, towards the end of his career, took up sculpture. It was therefore particularly exciting that, in 1998, Richard Staughton was able to negotiate the loan, from Gimpel Fils Gallery, of a marble sculpture by Hepworth from 1963 called *Pierced Form (Santorini)*. It was prominently displayed at the entrance to the Dermatology Department, and was later replaced by a further sculpture called *Disc with Strings (Sun)*, from 1969, of polished bronze.

We were also able to negotiate the loan of other works of sculpture from the Arts Council, including works by Barry Flanagan, Andy Frost, Phillip King and Anthony Caro. When these works were acquired in March 1995, they were 'unveiled' for us by Lord Gowrie.

We thought the introduction of music was an important part of our brief and very early on put money aside for a performing arts co-ordinator. An early addition was a four-year arrangement with the City of London Sinfonia, which involved informal concerts with quartets and quintets and participation, particularly with the elderly and paediatric patients, but also obstetric and HIV patients. Every sort of musical activity, from individual musicians playing to patients, to regular informal concerts and large orchestral works, was included. About 220 musicians were involved in the programme. The introduction of opera followed a suggestion by Jeremy Isaacs, who was then chairman of the Royal Opera House, and whose daughter was a patient. He contacted us to ask if we would consider members of the chorus of the Royal Opera House coming informally to sing on the stage, which was, of course, a wonderful success, reflecting again the excellent acoustics of the atrium.

A performance of Thomas Tallis's forty-part motet *Spem in alium* transformed the hospital, as reported by Susan, into 'a cathedral of sound'. Children of all ages performed *Peter and the Wolf* with Patricia Hodge as narrator, and opera naturally followed. Three performances of *Cosi fan Tutte* by Pimlico Opera in 1999, with Wasfi Kani, was thought to be the first complete opera to have been performed professionally in a hospital. There followed productions of *La Bohème, Traviata* and *Serglio* in 2000. Two productions of *Cinderella* by Rossini followed a week-long residency on the children's ward, during which time young patients designed and

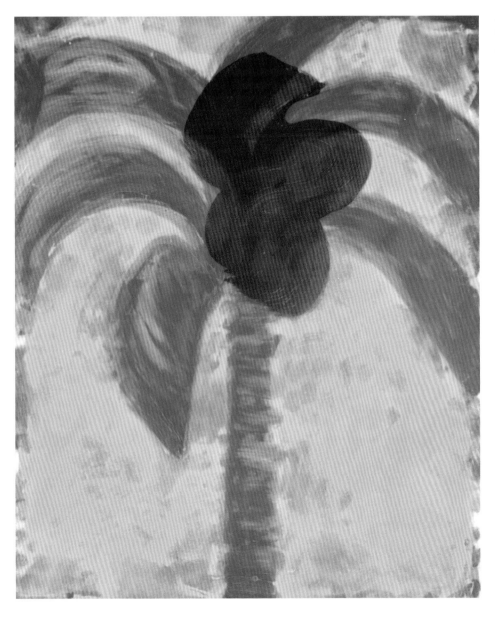

26. Sir Howard Hodgkin (1932-2017)
Flowering Palm (Heenk 89), 1990-91
hand coloured etching with
carborundum, 169.5 x 140 cm.
Chelsea and Westminster Hospital

made the set for the opera.

There was also a three-year programme with students from the Royal College of Music, performing ensembles in the mall and on the wards, and other innovative musical experiences. Multi-ethnic performances were arranged through the Guildhall School of Music with Indian, Chinese, South American and African music, and choirs and dance groups.

Andrew Ritchie, the founding inventor of the folding Brompton bicycle, likes jazz. His first hip was replaced in the old Westminster Hospital and his second in Chelsea and Westminster. He later found he could help to sponsor a sixty-minute

jazz composition by Jonathan Cohen, inspired by the poem *Little Gidding* by T.S. Eliot, which, other than initially being performed in the village of Little Gidding in Cambridgeshire, then had its premiere in the hospital.

I retired from the NHS and left the project in 2002, at which time we had raised and spent approximately £4.5m and had acquired around 1,500 works, whose value, for insurance apparently, had gone up by about 60 per cent.

Leaving the operating theatre in the middle of the night after finishing the last emergency operation that I undertook, I heard the soft wailing of music. I walked along the walkway to the back of the hospital and there on the stage was a man sitting far back in a chair softly playing the saxophone. The effect was rather magical under a bright night sky of moon and stars shining through the roof. I listened for a while. When I got home I rang the hospital to ask about it. The lady on the switchboard told me he had just turned up with a chair and a saxophone at about 2 a.m. and played quietly. He had now just left, taking his chair with him. He'd been there for about two hours. 'We thought it was rather wonderful,' she said. And indeed it was.

2 A JOURNEY THROUGH TRANSFORMATIVE ART
RICHARD CORK

Most adults and children who enter a hospital, often accompanied by the scream of an ambulance siren, feel anxious. Whether they are relatives of someone already inside the building, or patients bracing themselves before undergoing treatment, these people can truly be described as vulnerable. They deserve something far better than a stark and bewildering medical environment, unalleviated by images of the world outside.

That is why the CW+ arts programme at Chelsea and Westminster Hospital must be applauded for providing such a refreshing alternative. As soon as we walk into the building, our eyes are greeted by Eduardo Paolozzi's lifesize figure who stretches out

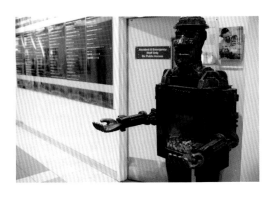

both his hands towards us. Although a red notice on the door beside him warns that the space beyond it is used by 'Accident & Emergency Staff Only', Paolozzi's sculpture invites us to pause and familiarise ourselves with his existence. He looks somewhat robotic, and yet this beckoning man appears frail as well. He might have undergone harrowing experiences in wartime, and his limbs could almost be described as

prosthetic. But there is nothing remotely aggressive or helpless about him; he seems gentle, and may even be grinning. Moreover, the inscription on the capacious box attached to his torso spells out in capital letters a positive message: 'The Healing Arts'. Slots incised in his ears and sturdy chin invite everyone to donate, and the money visible within the box suggests that plenty of people appreciate the enlightened thinking behind the hospital charity's art venture.

Generated by the inspirational enthusiasm of James Scott, who realised how much visual art, in particular, can transform hospitals, this admirable project has ensured that Chelsea and Westminster's interior is alive with an astonishing variety of paintings, sculpture, prints and works in alternative media. Many of them were made specially for the locations they inhabit and they aren't confined only to the largest spaces within this luminous building. A walk past the Paolozzi and descent to the lower-ground-floor level on an escalator is enhanced by a delightful fish-tank, while Bruce McLean's *Sombre Sombrero* enlivens a wall very near the entrance to the bereavement office. As its title suggests, McLean's print does not offer a bland image of happiness. Instead, it acknowledges the darker side of life, also conveying, through

2. John Hoyland (1934–2011),
Hating and Dreaming, 1990,
screenprint, 112.5 x 105 cm.
First Floor, X-Ray,
Chelsea and Westminster Hospital

McLean's innate vitality as an artist, his affirmative sense of humour. A comparable mixture of emotions can be found in John Hoyland's prints, ranged along a corridor leading down to the medical library. The title he gives one these images, *Hating and Dreaming*, indicates that Hoyland might even be dramatising the impact of a nightmare. The blackness dominating its background certainly has a nocturnal quality, while the yellow and red splashes evoke alarming moments in the dream. Although Hoyland was an abstract artist, there is even a hint of a ghostly facial profile on the left side of this print. But the whole image can be savoured for its sensuous flair, and Hoyland knew

3. Lucy Le Feuvre (b. 1958),
Arc and Vessel, 1994,
wood, 280 x 210 cm.
Lower Ground Floor,
Academic Atrium,
Chelsea and Westminster Hospital

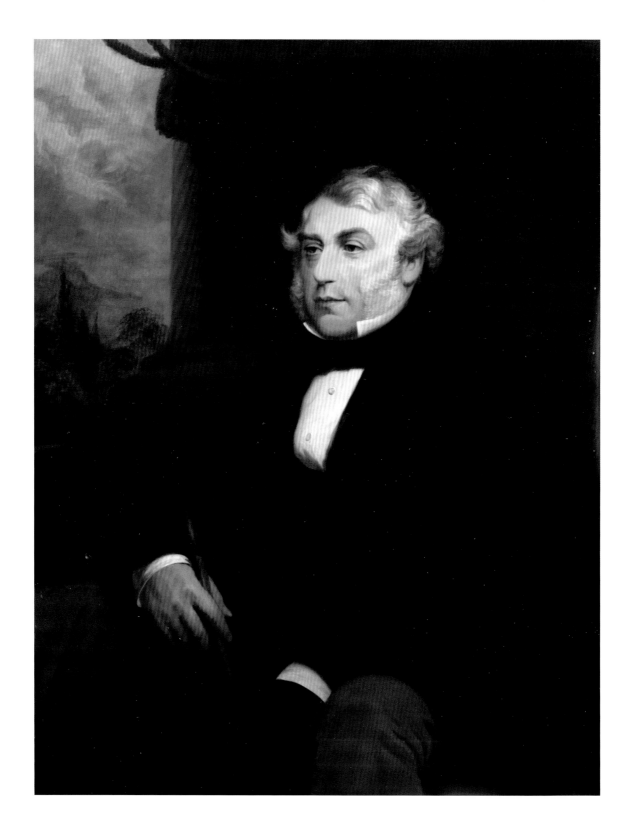

4. Opposite.
George Hayter (1792–1871),
James Chadwick, c. 1860,
oil on canvas, 112 x 84.5 cm.
Chelsea and Westminster Hospital

exactly how to deploy colours that seduce the eye.

Patients come down to the main lower ground floor for blood tests, and they are likely to feel intrigued by Lucy Le Feuvre's *Arc and Vessel*. Visible through a glass door, the main form seems to rise, like some mysterious organic phenomenon, from the earth below. The notion of growth can be positive or negative in a medical context, yet the whiteness of Le Feuvre's painted wooden seed pod is quietly reassuring. And the arc curving around it looks protective, suggesting that the hospital is predisposed to the idea of nurturing and sheltering.

The minimalism she deploys in this sculpture could hardly be further removed from the academic paintings we find nearby. Here, in an impressively well-researched and visually intriguing display, a wall-sized installation summarises the hospital's complex history. Dignified portraits of eminent medical men were favoured in the past, like Sir George Hayter's painting of James Chadwick, a stern, mutton-chopped sitter dressed in formal attire fit for a grand dinner. Hayter himself was an enormously successful nineteenth-century portraitist. Despite the scandal which erupted when his mistress, Louisa Cauty, poisoned herself with arsenic in 1827, his work impressed Queen Victoria so much that she ended up knighting Hayter and appointing him as her Principal Painter in Ordinary.

Hayter's traditional approach to art is utterly removed from the adventurous Julian Opie, whose engaging images of walking figures animate the walls in the outpatients department on the lower ground floor. Executed in lenticular acrylic, these four people seem to be making their way to an appointment. So we can all identify with them, and Opie's decision to give their names ensures that they emanate a sense of companionship. It is all too easy for a patient to feel very alone when walking through long hospital corridors, and Opie's ability to convey an informal vitality in figures like the sprightly, fair-haired *Sian* succeeds in alleviating this oppressive sense of isolation. Suddenly, as we move past her, Sian and the other figures spring into activity like animated versions of people on the move in a Futurist painting. Opie's images amount to a celebration of everybody, and this delightful warmth increases when we reach the outpatients atrium. Looking up, we are amazed to glimpse Patrick Heron's joyful banners swinging gently through space far above us. Their appeal is instantaneous, and makes us eager to encounter them again further up the building.

Before then, walking through to another atrium that stretches up from the ground floor as high as the light-filled hospital roof, we discover Allen Jones's vivacious *Acrobat*. Celebrating the human body at its most defiantly energetic, this flamboyant and brightly coloured steel sculpture fills an entire multi-level area of the building with unquenchable optimism. Cheeky humour is evident here as well. On one side, *Acrobat* greets us with a gigantic pair of red lips, while on the other an astounded yellow face stares with plump, glistening fruit where the mouth should be. Above, a yellow leg thrusts outwards, while a blue limb shoots upwards through the atrium's empty space. Right at the top, a large red ball is balanced on a blue foot, thereby adding a strong feeling of suspense to the entire sculpture. Jones clearly sees *Acrobat* as a circus performer. It rewards onlookers who have time to circumambulate and scrutinise the sculpture from different angles. Not far away, a polite hospital sign warns:

5. Julian Opie (b. 1958),
Sian Walking, 2010,
lenticular acrylic, 46.4 x 83.2 cm.
Chelsea and Westminster

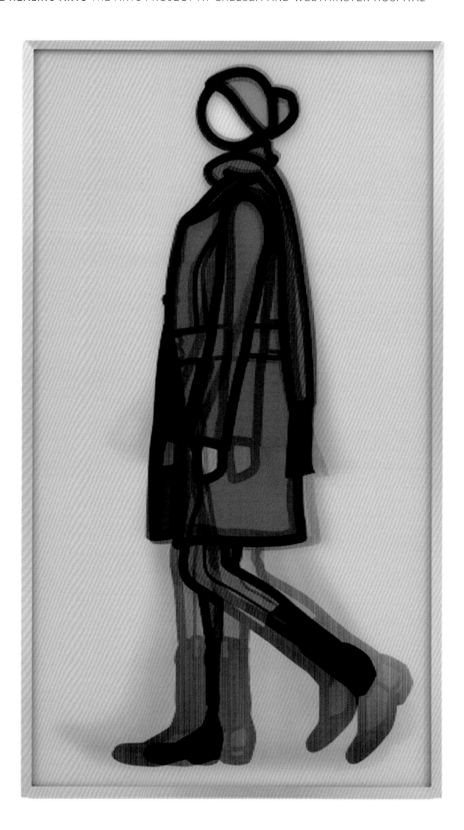

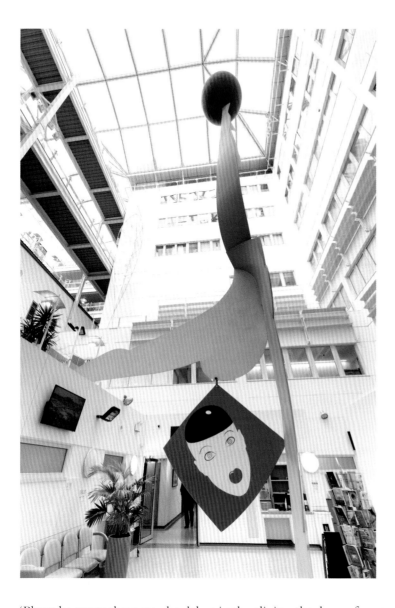

6. Allen Jones (b. 1937),
Acrobat, 1993, painted corten steel.
The Atrium,
Chelsea and Westminster Hospital

'Please be aware there may be delays in the clinic – thank you for your patience'.
But rather than feeling bored or frustrated, patients waiting here are lucky enough to
savour *Acrobat*'s extraordinary sprightliness.

In the corridor leading out, a far more simplified and abstract vision can be
found in Sean Scully's *Large Mirror*. This boldly executed etching and aquatint does
not provide us with a reflection, as its title suggests. Instead, Scully restricts himself to
a sequence of horizontal forms thrusting through space. The warmth of brown and
cream on the left is juxtaposed with a colder black and white alternative on the right.
The contrast is invigorating, and prepares us for the surprise of finding Julian Opie's
four animated figures walking backwards, in response to our own movements, on the
way out.

7. Opposite.
Sean Scully (b. 1945),
Seven Mirrors Plate 7, 1997,
etching and aquatint, 65 x 54.5 cm.
Chelsea and Westminster Hospital

Ascending the escalator to the main atrium, we glimpse different artworks on so many levels, all the way up this visually stimulating interior. Then, on the right, four prints by Sandra Blow look immensely refreshing. As her vigorous surname promises, Blow's images evoke the ever-shifting dynamism of blustery weather. *Split Second* lives up to its arresting title by summarising the instantaneous clash between white, black and scarlet forms interacting against a backdrop of verdant green. *Side Effect* and I*nside Story* are equally dramatic, evoking deep sea and radiant sunshine respectively. But the most compelling of Blow's four prints is *Through and Beyond,* where several white and black forms seem to be fighting it out with a pool of splashy blood-red.

The sheer vigour of Blow's works possesses an immediacy which ensures that she will win the attention of many people as they move through the hospital. Soon afterwards, we find ourselves gazing at an equally compelling series of prints by Eduardo Paolozzi. His inspiration is primarily urban, bringing together a whole array of diverse images culled from a keen-eyed observation of London. But not far away, a wholly different source enriches the paintings by Melvyn Chantrey. His set of twelve murals called *Waterfalls* were among the first artworks ever commissioned for this building. He painted them on adjacent corridor walls all the way up to the fifth floor. On the lowest level, Chantrey is at his most abstract: suggestions of plant life, reflections and rainbows can be detected here, yet they are very freely handled and broken up by his constant awareness of light. If we ascend the building and follow the progress of these murals, our eyes adjust increasingly to Chantrey's mark making and recognise, at the summit, that splashing waterfalls were indeed the fundamental inspiration behind all his lyrical paintings on view here.

Moving on through the building, we realise that one of the prime merits of Chelsea and Westminster's attitude to artworks lies in its overall awareness of the interior spaces in their entirety. Walking along the corridor leading to the medical day unit, we find Albert Irvin's series of seven gouaches. Executed with a vivacity that matches their preoccupation with blazing colours, they are well worth relishing in their own right. But Irvin made them as a sequence of studies for a large painting called *Hollywood* which can be found further up the hospital. Named after a nearby road, it looks like an ecstatic celebration of life at its most sensuous and exhilarating. So do the gouache studies downstairs, and their freshness is bound to delight plenty of viewers as they find their way through the building.

Looking up as we reach the final atrium on the left, our eyes are captured at once by Edward Bawden's mural-size paintings called *Fantasy on Islamic Architecture.* They look site-specific, as if the hospital had commissioned them for these particular walls. Yet the truth is that Bawden's monumental images arrived at Chelsea and Westminster building in 1996, after their removal from BP's London headquarters. Painted three decades earlier for its restaurant in Britannia House, they must have offered the diners an evocative reminder of the world where so much oil had been found. But after their transfer to the hospital, they took on a far wider identity. Bawden ensures that we focus on the powerful patterns dominating the architecture depicted here. In some segments of the paintings he focuses on this ornamentation in an almost abstract way. Elsewhere, though, the Islamic buildings are depicted in the far broader context of

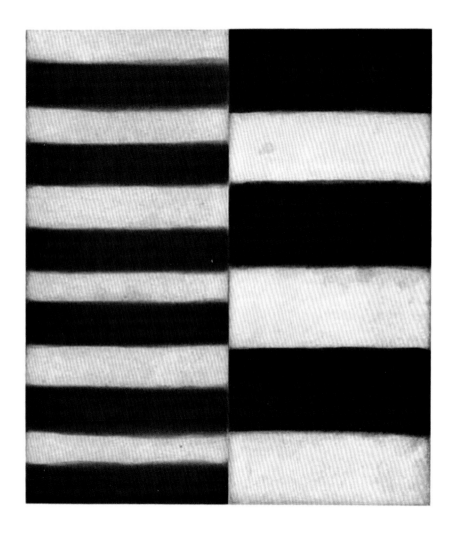

8a. Sandra Blow (1925–2006),
Split Second, 1993–94,
screenprint, 119 x 119 cm.
Chelsea and Westminster Hospital

8b. Top.
Sandra Blow,
Side Effect, 1993–94,
screenprint, 119 x 119 cm.
Chelsea and Westminster Hospital

8c. Bottom
Sandra Blow,
Inside Story, 1993–94,
screenprint, 119 x 119 cm.
Chelsea and Westminster Hospital

8d. Sandra Blow (1925–2006)
Inside Story, 1993-94
Screenprint, 119 x 119 cm.
Chelsea and Westminster Hospital

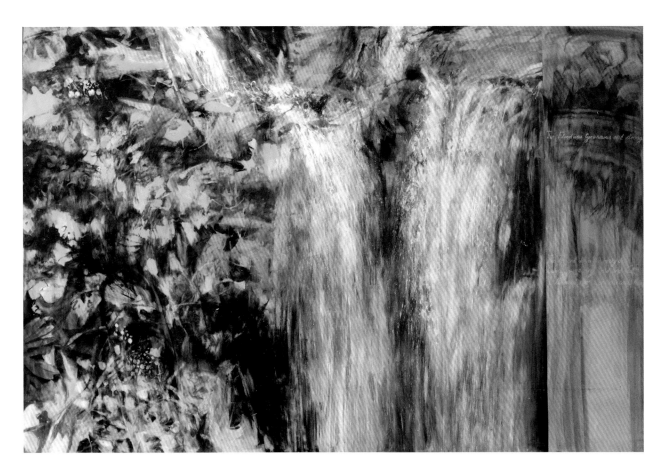

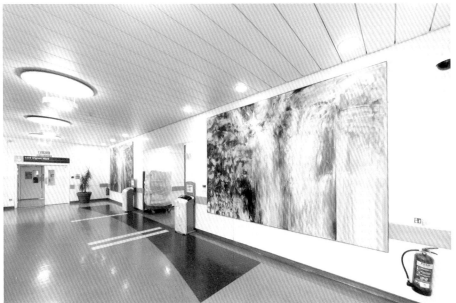

9a & b. Melvyn Chantrey (b. 1945),
Waterfalls, 1992,
acrylic on board, 243 x 365 cm.
Chelsea and Westminster Hospital
Photo: Sam Roberts

13. Albert Irvin (1922–2015),
Hollywood, 1995,
acrylic on canvas, 137 x 685 cm.
Fracture Clinic,
Chelsea and Westminster Hospital

the landscape beyond, where the sunlit warmth of hillsides dominate the horizon with their sculptural power. The strength of these paintings undoubtedly derives from Bawden's own personal exploration of the Middle East, where he had worked as an official war artist during World War II.

Anyone who reaches the hospital's welcoming café area, and sits down for some much-needed refreshment, can look up and easily become captivated by Sian Tucker's *Falling Leaves*. She installed them in this atrium space in 1993, and since then her mixed-media images of leaves have become so well-loved that they are now refabricated in aluminium. The hope must be that they will last forever, since *Falling Leaves* are clearly irresistible to many of their viewers. As Tucker's title for the work suggests, the principle idea which excited her was autumnal plants shedding their leaves so quickly that they are caught here descending through space. Rather than plummeting, though, they float very gently and almost appear to revolve. Tucker ensures that air blown from vents installed in the floor below make this lyrical movement possible. So the relationship between one leaf and its neighbours is constantly changing, and the occasional bird can also be detected flying through them. Although she derives her vision from a wide variety of sources, the audacious painted paper cutouts created by the elderly, frail Matisse near the end of his life are surely a prime inspiration.

If we travel up the escalator from the café to the first floor, one of the most ambitious installations greets us on no less than five walls outside the Saturn Ward. Here, Joy Gerrard has enlivened the pale architecture by placing as many as 450 stainless steel spheres and rods in clusters across a 30 metre space. They range from large globular forms reminiscent of planets to far smaller shapes which crowd together as if seeking reassurance from each other. Maybe they feel apprehensive about the linear sharpness of the rods nearby, which could be seen as aggressive or

10. Edward Bawden (1903–89),
Fantasy on Islamic Architecture, 1966,
oil on panel, diptych, each panel
412 x 914 cm.
Chelsea and Westminster Hospital

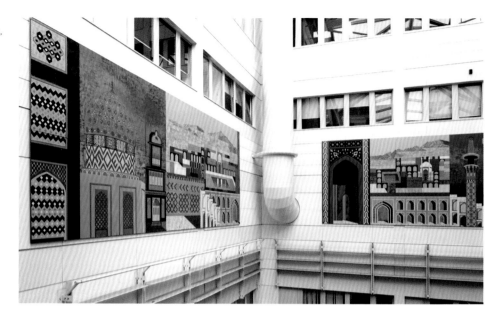

11. Sian Tucker (b. 1958),
Falling Leaves, 1993, mixed media.
The Academic Atrium,
Chelsea and Westminster Hospital

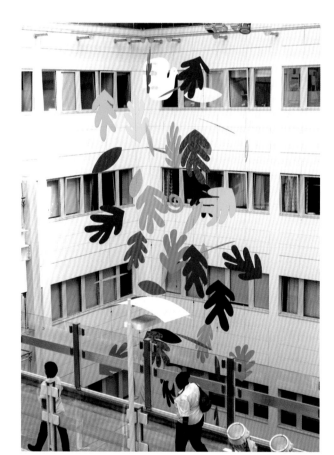

12. Joy Gerrard (b. 1971),
Assembly/450, 2011,
polished stainless steel.
The Atrium,
Chelsea and Westminster Hospital

even threatening. But Gerrard gives the entire work a reassuring title: *Assembly/450*. Far from seeing it as a potential war-zone, she wants to take our imaginations away from everyday hospital reality and enter a region as free-flowing as outer space. She also rewards everybody who takes a much closer look at the work: viewed near-to, these highly polished elements offer very intense reflections of the architectural spaces surrounding them. According to a distant notice, some of the visitors who scrutinise Gerrard's work must be on their way to or from the neo-natal unit. And many patients now find *Assembly/450* so fascinating that they take photographs of their own gleaming reflections to post on Instagram.

No such activity disrupts the atmosphere of calm meditation in the hospital's chapel, a modest-sized room where the images in stained-glass windows include a commemorative portrait of King George VI, who underwent a major cancer operation in 1951 for the removal of one lung. It is a modest image, and does not prevent us from gazing at the large altarpiece by Paolo Veronese that dominates the entire chapel. Originally painted in the 1580s for the Italian church of *San Giacomo di Murano*, it is an astonishing artwork to discover in a modern London hospital. Even non-believers will find themselves impressed by Veronese's consummate ability, at a late stage in his prolific career, to give *The Resurrection* an immense, dynamic emotional conviction. The nearest figures are found in the shadowy foreground, where sleepy soldiers awake with startled concern from the darkness cast on them by Christ's tomb. Above them, two resolute angels have pulled back the heavy lid that once enclosed

13. Paolo Veronese (1528–88),
The Resurrection of Christ, 1587,
oil on canvas, 273.4 x 156.2 cm.
The Chapel,
Chelsea and Westminster Hospital

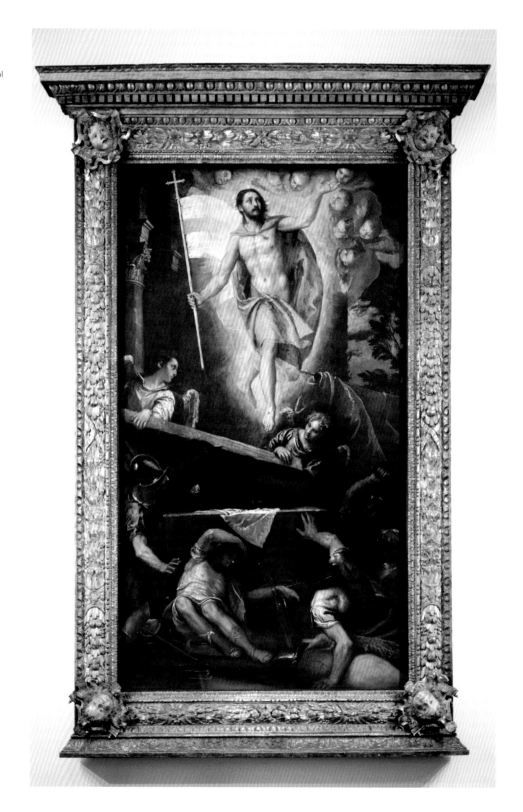

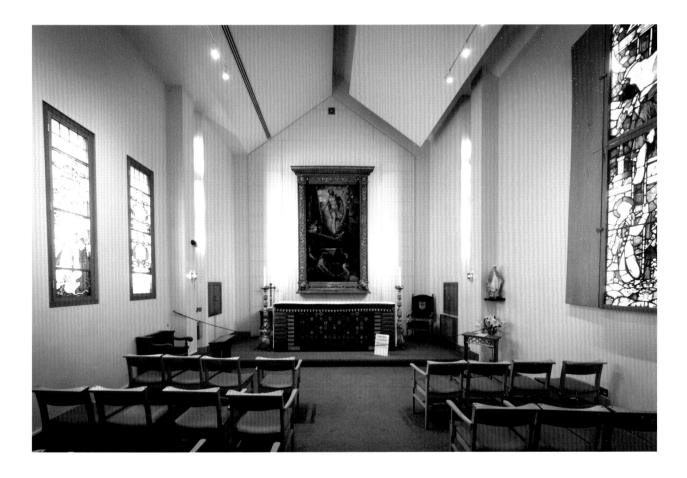

14. The Chapel,
Chelsea and Westminster Hospital.
Photo: CW+

the corpse, enabling Jesus to ascend with an undulating, wind-blown flag towards the sky. But Veronese captures the anxiety in Christ's face as he undergoes this miraculous transformation. There is nothing at all complacent about his rebirth, and he looks vulnerable as his left hand reaches out to touch the children's heads floating like cherubims in the luminous glow around him. As a result, the entire painting is filled with tension, and the vigorous freedom of its execution enhances the profound sense of wonder generated in our minds by this Venetian master.

So we have every reason to thank the special trustees of Westminster Hospital when they decided in 1950, on the advice of its chaplain, Canon Christopher Hildyard, to acquire *The Resurrection*. He must have been as determined and enlightened as James Scott would become in the early 1990s after contacting Patrick Heron and urging him to design a trio of large banners for the atrium. Although he had previously created eight modest silk hangings for Tate Britain, Heron shied away from this hospital project at first. But Scott persisted with admirable conviction, and eventually succeeded in persuading the reluctant artist to make three gouache designs for this ambitious venture. The outcome, executed in Japanese silk and dramatically suspended from trapezes designed with great ingenuity by Heron's daughter and

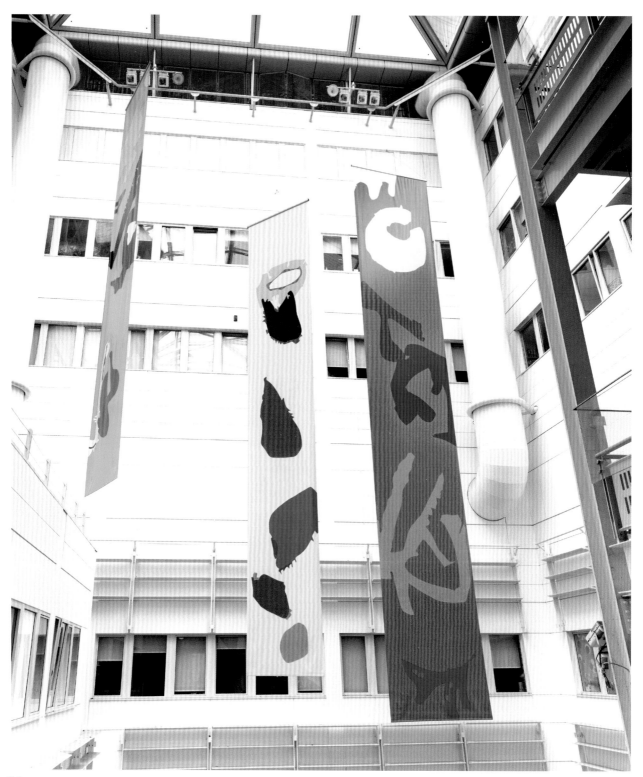

15. Opposite
Patrick Heron (1920–99),
Three Banners, 1992-3,
printed PVC on rigging.
The Atrium,
Chelsea and Westminster Hospital

her husband, is a triumph. This trio of long banners emblazon the tall atrium space with rich, sensuous colours as they revolve gently in space. Although the forms they contain look abstract, and Heron simply titled the entire work *Three Banners*, they evoke the heat and light of high summer. I was once lucky enough to visit Heron at his Cornish house, called *Eagles Nest*. With enormous enthusiasm, he showed me the garden where a proliferation of colours emanated from the plants and flowers thriving in this verdant paradise. He clearly gained enormous stimulus from the natural world around him. And looking at his *Three Banners*, I feel convinced that they can be seen as an ecstatic tribute to the joy Heron gained from the irresistible fertility of the garden he had shown me with justified pride down at Zennor.

The life-affirming potency of a work like *Three Banners* in a hospital context can never be overestimated. Patients gain nothing from the bleakness of a medical building where art has no role to play, whereas they can benefit in all kinds of ways from the imaginative nourishment provided by art as heartfelt as Heron's. Plenty of people walking down the x-ray corridor are feeling nervous about the possible outcome, and others may already be struggling to cope with an ominous illness. So they are bound to benefit from the unabashed vivacity of a print like Gillian Ayres's *Leveret's Leap* (Fig. 16). The title indicates that her starting-point was the joyful, impulsive energy of baby hares who suddenly discover how to hurl themselves through space. Yet Ayres, a pioneering British abstractionist who came to the fore in the Situationist exhibitions of 1960–61, would never have been content with offering a straightforward depiction of the leveret's burgeoning physical prowess. She is associated with creating vigorous, large-scale paintings suffused with rich and often scintillating colours. That is why outspoken drama is the governing impulse in *Leveret's Leap*. Looking at this explosive composition, we can glimpse possible references to staring eyes, a gaping mouth, gesticulating limbs and landscapes nearly melting in the heat. They generate an almost tropical intensity, so Ayres would clearly like to overwhelm us with the intoxicating impact of her restless forms and colours.

One of the many strengths of the art displayed with such vigour at Chelsea and Westminster Hospital is the prominence given to women artists as well as their male equivalents. In the x-ray corridor we also find a work by Wilhelmina Barns-Graham, who in 1949 declared, 'I am interested in using abstract forms mainly insofar as they are derived directly from natural sources by means of simplification within the movement of the picture itself.' She had journeyed a long way from the 'primitive' style deployed in her early works as a young artist in St Ives, proclaiming a debt to Alfred Wallis. After World War II, she went to Switzerland and boldly explored the north face of the Eiger. Here, under

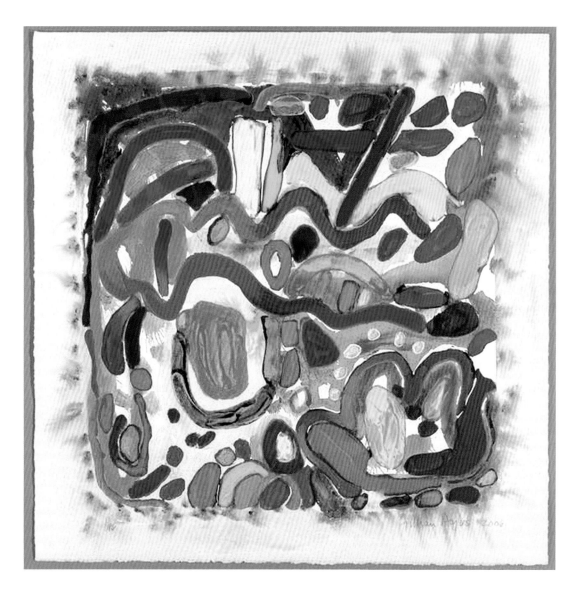

16.
Gillian Ayres (1930–2018),
Leveret's Leap, 2005,
carborundum etching with
hand-painting in acrylic 76 x 76 cm.
First Floor, X-Ray,
Chelsea and Westminster Hospital

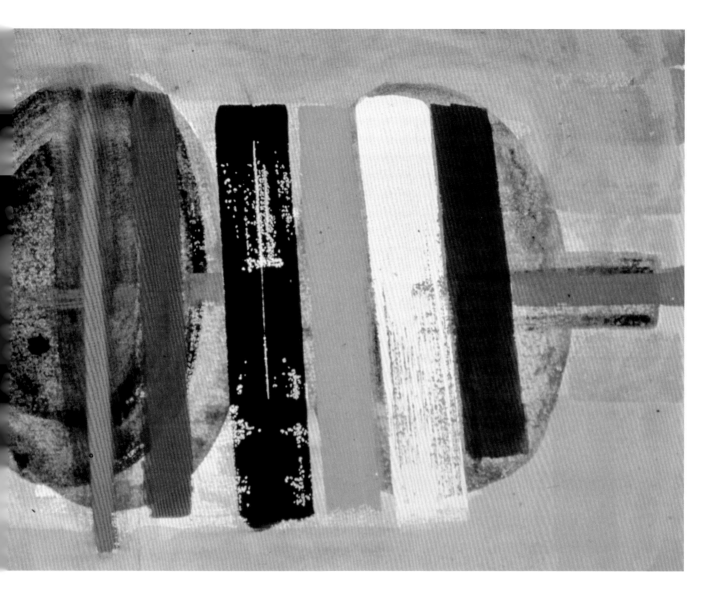

this towering colossus, she made her way carefully across the perilous Grindelwald Glacier with the assistance of a local guide. Yet Barns-Graham wasted no time in making impressive drawings and paintings of the spectacular sights she had witnessed there. Her restless appetite for colour drove her to travel a great deal during the 1950s, working in Italy and the Scilly Isles as well as Spain, France and the Balearics.

17. Wilhelmina Barns-Graham (1912–2004),
Untitled, 1995,
oil on paper, 56 x 76 cm.
X-ray corridor,
Chelsea and Westminster Hospital.
© Wilhelmina Barns-Graham Trust

18. Joe Tilson (b. 1928),
Geometry?, 1965,
screenprint, 55 x 55 cm.
First Floor, Dermatology,
Chelsea and Westminster Hospital.
© Joe Tilson. All Rights Reserved,
DACS/Artimage 2018.
Image: © National Galleries
of Scotland

In the same x-ray area of the hospital, we come across Joe Tilson's *Geometry?*, which seems at first glance to put forward a more abstract vision than Barns-Graham's. He focuses here on circles of pale blue, yellow and orange, but as our eyes absorb the print in its entirety we realise that Tilson may well have derived these forms and colours from something he initially observed. After all, for many years he has spent much of his time in Venice, and gains enormous stimulus from the light, water, architecture and sky surrounding him there.

Although Henry Moore's most ambitious works always took the form of sculpture, he was an outstanding draughtsman as well. Both these aspects of his art can be appreciated in his print *Sculptural Forms* where, as the title suggests, he delineates an outdoor location filled with the kind of carvings and bronzes Moore himself produced. The setting could well have been inspired by the extensive stretch of land around his own house and studio in Much Hadham, Hertfordshire. He moved there after bombs damaged his London studio, and *Sculptural Forms* was made in 1949. Although World War II had come to an end, Moore gives this print a distinct sense of unease. The upright mother, who shelters a small baby-like form within her own body, appears defensive, and another sculpture looks trapped within the metal bars of a globe-like form on the left. Meanwhile, in the distance, a whole cluster of figures

19. Henry Moore (1898–1986), *Sculptural Objects (School Prints)*, 1949, lithograph, 75 x 48 cm. Reproduced by permission of The Henry Moore Foundation

have a ghostly appearance, as if still haunted by the devastation they had witnessed during the 1940s. But they also look determined, like Moore himself, to assert the affirmative presence of outdoor sculpture in the post-war world.

Georges Braque, whose *The Bird* can be found near Moore's print, knew all about the horror of military conflict. He had been wounded during World War I and only began painting again after a prolonged convalescence. Even so, Braque managed to put the nightmare behind him, and by the time he created *The Bird* a new spirit of playfulness had entered his work. A fish, some flowers, a large star and three leaves are among the simplified forms that float around the bird's prominent body. The overall mood is poetic and beneficent, created by a gentle artist whose later paintings often include an enormous bird in majestic flight through a studio interior.

20. Georges Braque (1882–1963), *The Bird (School Prints)*, 1949, lithograph, 48 x 75 cm. © ADAGP, Paris and DACS, London 2018

21. Andy Council (b. 1974), *Mother and Baby Rhino*, 2015, vinyl installation. CW+ MediCinema. Photo: Dunstan Baker

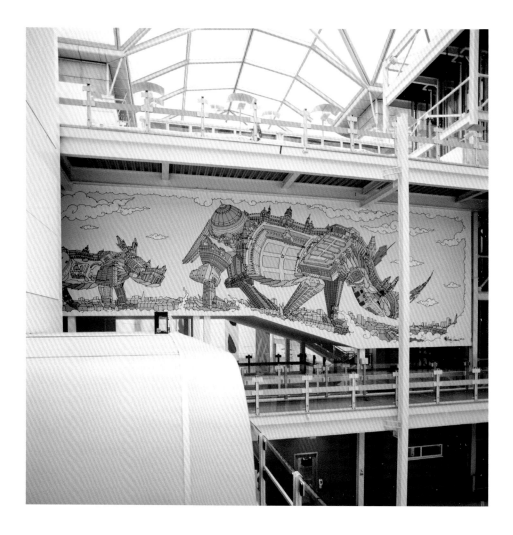

22. Opposite
Diane Maclean (b. 1958), *Walking*, 1999, powder coated steel. Chelsea and Westminster Hospital. Photo: Diane Maclean

Walking past the CW+ MediCinema, we discover creatures of another kind striding across its wall. *Mother and Baby Rhino* is the title of this large vinyl mural, and Andy Council cleverly constructs their bodies out of London's architecture – including Victorian buildings as instantly recognisable as the Royal Albert Hall and the Natural History Museum. Cathedral spires become horns rising from the rhinos' heads, while skyscrapers are transformed into the animals' legs. We are invited to savour Council's fanciful inventiveness, even though we may also wonder about the safety of the city which looks so vulnerable beneath the rhinos' massive feet.

Not far away, Diane Maclean explores human frailty in a sculpture called *Walking*. Three pairs of legs, each one parading a different colour, move through space. They are clearly prosthetic limbs, and remind us of how orthopaedic surgeons strive to transform the lives of disabled people. So Maclean conveys the effort involved in making these limbs move across the floor, yet at the same time she celebrates their mobility and defiant resolve by giving them buoyant, light-hearted colours.

Then, as we move further up the building, Richard Smith astonishes us with *Seraphim*, a spectacular work where kite-shaped pieces seem to dance, collide, clash and almost erupt from the wall. Smith's choice of title suggests that he sees them as celestial beings associated, above all, with love, light and purity. But he conveys the strength of their ardour as well, and the prominent space occupied here by *Seraphim* means that it can be seen from several different floors of the hospital.

That is why ascending this tall building proves so visually rewarding. While walking up, we can look down on Allen Jones's *Acrobat* and realise how its red ball, poised at the very top, is balanced there with such bold prowess. Patrick Heron's *Three Banners* and Sian Tucker's *Falling Leaves* take on refreshingly different identities in their light-filled atrium spaces when seen from above rather than below, making us appreciate even more just how deeply CW+ and Chelsea and Westminster are committed to stimulating everyone within the building.

Up here, Melvyn Chantrey's sequence of murals reaches its climax with a spectacular image of a tumbling, splashing waterfall. And Thérèse Oulton offers us *Correspondence 2*, a shimmering, abstract image, redolent of floating leaves, snowfall and frosty rock formations.

By the time we reach John Copnall's *Radiance II*, where shafts of many different colours explode outwards, our spirits have been lifted so many times that we wish all hospitals, across the world, could likewise be enhanced by such a prodigious abundance of visual richness.

23. Opposite.
Thérèse Oulton (b. 1953),
Correspondence 2, 1990,
oil on canvas, 213 x 234 cm.
Chelsea and Westminster Hospital

The specified locations of artworks referenced in this chapter are correct as of 1 January 2019, but are subject to change.

24. John Copnall (1928–2007),
Radiance II, 1994,
acrylic on canvas, 173 x 259 cm.
Chelsea and Westminster Hospital

3 A SENSE OF PLACE AND PURPOSE
DR. ZOE PENN

A few months ago, I found myself carrying home a painting I had not expected to buy. I spotted it at an art fair in the northern Kentish town of Whitstable – a typical seaside town with lots of cafés and walkways along the beach. From there, an endless sea and sky stretch towards the horizon. The painting captured the scene perfectly. Most of the canvas is dedicated to sky, with a little rim of sea and land detailed in a thin sliver at the bottom. Acting on impulse, I bought it and carried it onto the train back to London.

It might not have been the most sensible purchase – the painting is too large for any one wall in my house. At the moment, it is propped up by the radiator near the front door. At its worst, this painting is annoying for getting in the way. However, it is noticed. Guests comment on its size, amused that it seems to be in limbo, on its way in or out of the front door. But then they ask about the painting itself. They comment on the colour palette, the wide sweep of the sky, and then about Whitstable itself. Every time someone comes over, we have a conversation about the town or the sea, and I am reminded of that day on the Kentish coast, grateful for the bit of it I brought back home.

ARCHITECTURE AND LIGHT

I often think of this sense of place in my role as Medical Director at Chelsea and Westminster Hospital NHS Foundation Trust. In addition to practising as an obstetrician, my job is to organise and motivate clinical staff across all wards. This makes me ultimately responsible for the quality of patient care but, in practice, my job is to make sure that medical, nursing and therapy staff are at their best. One of my main concerns is how to maintain active engagement with staff – dozens of clinicians across two sites – which is, frankly, impossible for one person. So, a common strategy is to give them a good place to work. That means a whole lot of things: training, education and salaries, of course. It also includes the environment they work in; I try to make them feel that theirs is unique.

I was struck by the architecture of the hospital building itself when we first moved into it in 1993. We had come from the old West London Hospital in Hammersmith, which was opened by Princess Alice in about 1860. It was a funny old building – the whole thing falling to pieces. It was clearly not up to the demands of a modern hospital with its cramped corridors, lack of natural light and isolated clinical areas. Chelsea and Westminster Hospital was built as an antidote to all that. When the clinical staff came into this new, clean, open clinical environment, the

first thing everyone did was to smarten themselves up. They dressed more smartly, kept their hair tidier and shined their shoes. They felt the need to dress for a new environment – somewhere that didn't feel like an old Victorian workhouse. At the old hospital, the standard uniform was not far from being a pink nylon woolly. You can imagine the change when everybody arrived here and put their black slacks on. They thought they needed to dress for it, which I think is a nice, simple and powerful response. By dressing smartly, staff members indicated that 'this environment deserves and expects that I present myself like this'. That desire to put effort into how they presented themselves was positively motivated – a carrot rather than a stick. In a wide-ranging report published in 2002, an overwhelming majority of staff at Chelsea and Westminster Hospital said they preferred the architecture of the modern, purpose-built hospital over a traditional hospital. While it may not have directly influenced clinical care, the marked difference in the way our staff carried themselves and presented themselves affected the feeling of working and being in the hospital.

In addition to the architecture of the building, the interior design – including lighting and colour schemes – is something clinical staff notice and are affected by. They will bring these issues up with me quite often, with lighting being perhaps the most common environmental concern. Of course, our staff need to be able to see properly in clinical areas, and fluorescent lighting is a practical, sustainable tool for this. However, the truth is, most patients don't need to be under such full lighting all day. In general, the more natural light we have in the hospital, the better. Researchers at Harvard Medical School first showed in 1981 that the quality and rhythms of natural light help regulate sleep cycles, which can easily be disrupted by electric

1. Accademia, Lightboxes, 2015–16, lightbox.
Chelsea and Westminster Hospital.
Photo: CW+

A fresh cup of tea, the extra mile: making someone else's day with a single smile.

2. Hannah Alice
Stairwell Commission, 2014,
printed Dibond throughout stairwell.
Chelsea and Westminster Hospital.
Photo: Ben Langdon/CW+

lighting at night. Our sleep cycles are regulated by a hormone called melatonin, and electric light, especially blue, cold fluorescent light, can suppress the secretion of melatonin, increasing stress and reducing the quality of sleep. Fluorescent lights are also more prone to flickering, both perceptibly and imperceptibly. We often hear patient complaints about the lighting as it is often too bright and not under their control. Wherever we can get rid of them, we will swap fluorescent lighting for adjustable softer lighting and custom-designed light boxes, which patients always prefer.

We have a wonderful building for natural light. Its layout allows us to minimise the fluorescent lighting. Even my office in the basement of the hospital has a window that opens into the cavernous atrium. The translucent roof above lets in natural light, on cloudy days, too, and it filters down. There are very few patient spaces that don't have access to this level of natural light or more.

TALKING OF ART

In addition to architecture, the art we put in various public and clinical spaces adds detail to our environment and the way we function within it. The hospital building itself is open and airy with lots of natural light, which makes it a wonderful

3. Laurie Hastings (b. 1981),
Geranium Forest, 2014,
printed Dibond panel, 260 x 129 cm.
Birth Centre, Chelsea and
Westminster Hospital.
Photo: Ben Langdon/CW+

environment for all sorts of art, including huge murals, framed photographs and sound installations. While I appreciate this art aesthetically, I really value the practical effect the art has on relationships throughout the hospital.

The presence of artworks in the hospital means that art reaches people who otherwise might not ever think about it. There is an artwork outside the labour ward, for instance. Some people visiting and working in the maternity unit hate it. However, like my Whitstable painting, it starts a conversation every time. One stranger will say to another, 'I don't like that.' The other will reply, 'Oh, don't you? Why don't you like that?' And they stand there and have a look at it. This may happen more often for artwork that people dislike. Even when people don't like it, I consider it to be a good thing: They have seen it, and have formed an opinion. It is the epitome of a 'conversation piece' in this way, prompting a dialogue about art in the middle of the working day – a conversation that's not, 'Did you give

4. Maddy Sargent (b. unknown),
A Child's View of London, 2016,
vinyl installation.
Chelsea and Westminster Hospital.
Photo: CW+

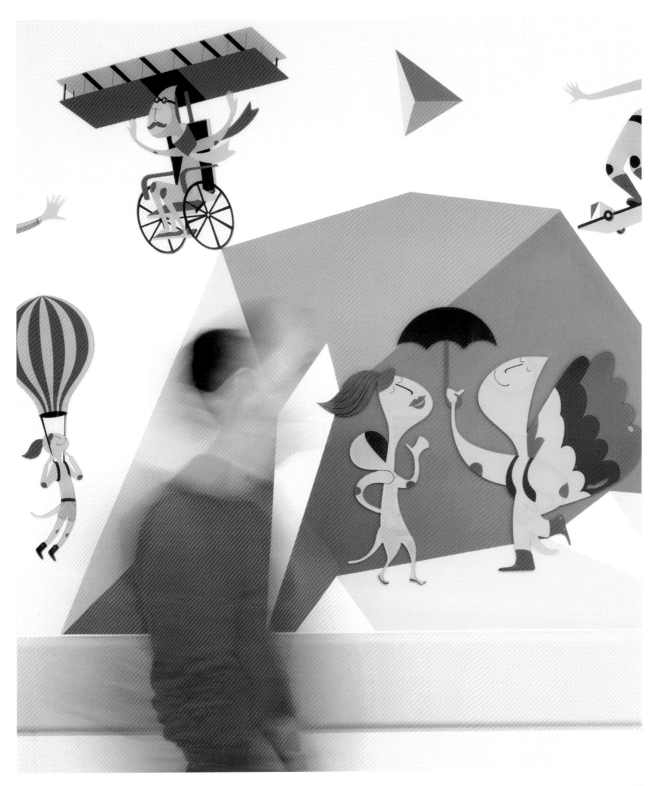

the morphine to the patient in bed bay A?' Many of these clinicians will never go to a gallery and stand in front of a piece of art. In the midst of the non-stop clinical and bureaucratic demands of the hospital, it is pretty amazing to be able to stop in the corridor for a minute to have this back-and-forth.

The art displayed throughout the public and clinical areas has become part of the brand of the hospital. It's made the working environment something our staff love and are proud of. If clinical staff members are proud of their environment, they'll want to live up to it. This attitude has carried through the move from the old hospital, to today. I have heard of staff telling acquaintances they work at Chelsea and Westminster Hospital, who respond, 'Oh, that's that hospital with the acrobat and the falling leaves and the rhino.' That type of interaction increases loyalty, engagement and discretionary effort.

In another section of the 2002 report, researchers at Chelsea and Westminster Hospital examined the attitudes of clinical staff towards their working environment. Using quantitative measures of preference, the researchers found staff experienced reduced levels of stress, improved mood and an increased likelihood to remain in their current job. When I read these results, I thought, 'Yes, we're doing something right here'. They were independent confirmation that we were beginning to achieve what we were working towards: an environment for everyone. With all of that in mind, I am confident our staff are more likely to stay here longer. This approach helps them to know the place more personally and have more contacts and relationships to depend on. These relationships improve teamwork, which, in turn, improves care. Such a cascade of effects is what occurs when we emphasise a holistic environment of care.

HAPPY STAFF, HAPPY PATIENTS

You might ask why I have focused on staff wellbeing rather than that of patients. In fact, staff and patient outcomes are closely linked. It might be obvious that we want to treat our staff well, but actually, staff wellbeing is the metric that would correlate most directly with positive patient experiences. If we want to ensure that people are safe and are cured in our care, we should ask: Are our staff happy working here? Because if you have happy staff, you have happy patients, and you have patients who are more likely to be engaged in their own recovery. So, I would not regard that as a soft connection.

Researchers agree about the value of this connection. Louise Hall and colleagues, in 2016, published a systematic review of research conducted in this area. After reviewing forty-six studies, they concluded that there was, indeed, a correlation between clinical staff wellbeing and patient outcomes. The Royal College of Physicians has also looked into this with a great degree of detail. In the 2015 report *Work and wellbeing in the NHS: why staff health matters to patient care*, they cited psychological stress among clinicians as a direct risk to patient safety through impaired clinical decision-making. Clinician burnout is a real problem across the NHS, and the Royal College of Physicians has proclaimed the importance of promoting 'health, wellbeing and engagement' among clinicians. However, it is very difficult to agree on, and adhere to, standards for how to approach it.

As medical practitioners, we are prone to thinking of these types of problems in

6. Painting workshop,
Nell Gwynne Ward,
Chelsea and Westminster Hospital.
Photo: CW+

medical terms. Our collaboration with CW+ has shown us there are other ways of dealing with these issues, including the focus on wellbeing. Wellbeing is a concept that has gained visibility in research, policy and practice in recent years, but its definition might initially seem broad enough to be almost meaningless. What do we mean by wellbeing? Does it mean simply feeling good? How is it measured and impacted? It is a term often used in the newspaper or on social media, and it has been defined in a variety of ways when applied to groups, from office workers to older people living with dementia.

The current interest in wellbeing might be traced back to the World Health Organisation's primary principle, first published in 1946: 'Health is a state of complete physical, mental and social wellbeing and not merely the absence of disease or infirmity.' Under these terms, you might begin to see the medical side of things as focusing on the 'disease or infirmity' part of this principle, while there is a whole world of non-medical elements that we can engage with. One of the most-cited ways of doing this is to foster positive, meaningful relationships between people, and we approach this by taking a look at the working environment. The environmental features of the hospital normalise and extend the relationships people have with one

7. Laurie Hastings (b. 1981), *Mint Pond*, 2014, printed Dibond panel, 260 x 129 cm. Birth Centre, Chelsea and Westminster Hospital. Photo: Ben Langdon/CW+

another; they learn more about each other if they are in an engaging work setting. Clinicians now have conversations over something that's not a specific medical problem. This also happens with patients, visitors, administrators or anyone else who might be passing by. It keeps the hospital from being a place we wander through, completely oblivious to our environment and our relationship to it.

TIME, PLACE AND ART IN MUSEUMS AND HOSPITALS

The sense of place museums provide is complementary to our vision of holistic, person-centred care here at the hospital. Indeed, a growing movement in both practice and research is expressed by the *Museums on Prescription* project, led by University College London. In conjunction with social prescribing models, the project has published dozens of studies measuring the wellbeing impact of cultural engagement provided by museums.

Studies of people with dementia have shown that museums give a sense of grounding in time and place. This is done very well at my favourite museum, the Uffizi Gallery, because the history of the building is so linked to its art. It was commissioned in the sixteenth century by Cosimo I de' Medici, who soon used it to house artworks commissioned by his family. The design for the building was by Giorgio Vasari, an architect and artist whose paintings still appear in the gallery today. As you look at the paintings, you don't have to imagine the world in which they were conceived and painted. You are already there. This creates a space that achieves the dual function of facilitating both grounding in time and place and exploration of the creative possibilities of art.

THE ART OF ASKING QUESTIONS

For me, evidence-informed design is what makes the arts for health project here very distinct from places who just want to prettify themselves. While we all want a nice environment, I think the extra value in our initiative is that we aim to demonstrate hard outcomes. This commitment is shown in the wide range of non-pharmacological research performed at the hospital. For example, Roger Kneebone leads the Imperial College Centre for Engagement and Simulation Science, which has brought in experts in fields such as bespoke tailoring, lacemaking and front-of-house service, to collaborate in improving surgical and care practice. Additionally, CW+ has led much of this non-medical research and development. With them, we have designed dementia-friendly wards that improve wayfinding and orientation. We have an intensive treatment unit that soothes delirium solely through creating a less medicalised environment.

In addition to these environmental improvements, patients across the hospital can choose to participate in activities, such as group music, movement and painting sessions. I have dropped in on these sessions in ward activity rooms, and they are just wonderful. While they give patients a certain level of distraction from the boredom of the hospital ward, there is growing evidence that social and artistic engagement

8. Gilles & Cecilie Studio (est. 2005),
Malika Favre (b. 1982),
Mercury, 2012–16, acrylic.
Chelsea Children's Hospital.
Photo: Jim Stephenson

improves patient experience and recovery. From my perspective, environmental and participatory arts have virtually no downside, and the upside is being more thoroughly understood every day. CW+ has its own research related to this field, beginning with the 2002 study showing reductions in patient cortisol, blood pressure and administered analgesia when exposed to live music and art. Just this year, a PhD thesis, in partnership with CW+ and the hospital, was written showing the benefit of engagement with the arts on loneliness, anxiety and wellbeing of hospital inpatients with dementia. That thesis, and further research, is showing us how digital media can best be used to improve patient wellbeing and recovery.

The arts input from CW+ has made us question our clinical care in ways we might not otherwise have done. For instance, they gave us the realisation that the environment can affect rates of delirium. Also referred to as 'acute confusional state',

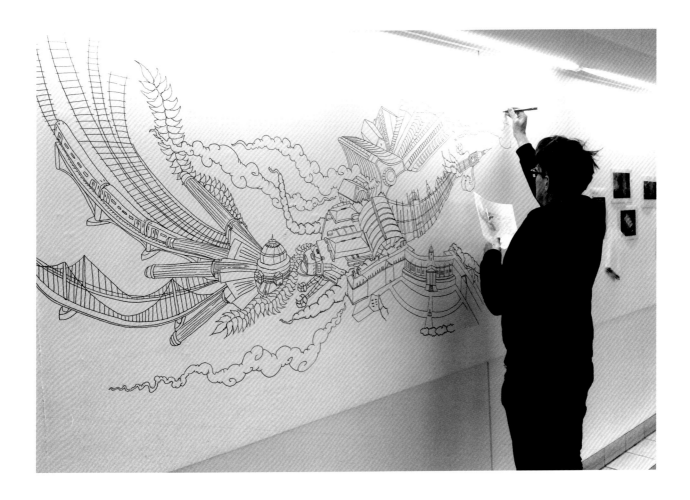

9. Andy Council (b. 1974), artist, preparing drawings for *Fox*, 2015, vinyl installation. MediCinema, Chelsea and Westminster Hospital. Photo: CW+

delirium is a mental condition whose cause can be difficult to ascertain, and is an example of an acute care challenge faced by patients on top of the original reason they came into hospital. While it can occur in any setting, delirium is associated with admission to hospital: the National Institute for Clinical Excellence reports rates between 20 per cent and 30 per cent among hospital inpatients. At one extreme, we can treat delirium by shooting someone full of sedative, which might make sense in the immediate, fast-paced acute care environment, but which doesn't consider the problem of the patient's potential mental disturbance six months down the line. Delirium was something we thought was an unavoidable part of an admission to the intensive treatment unit, that we just had to live with. We did not have any reaction more nuanced than, 'Let's give them a heavy sedative.' It's not within our armamentarium. If you've got a hammer, lots of things look like they need hammering. CW+ has a whole different set of hammers, and these make some things soluble that wouldn't otherwise work with the usual strategies. The fact that we can collaborate on patient care in this way is really rather unique.

10. Birth Centre, Chelsea and Westminster Hospital.
Photo: CW+

THE PLACE OF BIRTH

The collaboration with CW+ art and design impacts my clinical practice as well. Before I was appointed Medical Director, I worked as an obstetrician here at Chelsea and Westminster Hospital, and I maintain my practice to this day. In a hospital serving the London areas of Kensington, Chelsea and Fulham, we treat a diverse group of women. When it comes to patient environment for these women, one size doesn't fit all. Fortunately, our different labour wards offer a variety of environmental and care experiences. Many international patients are treated on the Kensington Wing, which has quite a clinical environment that represents their expectation of what a hospital should look like. However, our birthing unit is very different. The objective there is for people to feel as close to a home environment as they can.

Researchers have recommended giving pregnant women a sense of control during pregnancy and labour. This is tied to a feeling of safety, which we try to emphasise through both care and environment. The King's Fund Charity published a series of reports on maternity and labour, finding that patients' feelings of safety were tied to their confidence in the clinician looking after them. While our patients are right to put their trust in their doctors, midwives and nurses, safety for a patient

is about more than medical expertise and drug prescriptions. Ideally, the pregnancy would be smooth enough not to need those things. So, in addition to safety in the medical sense, we try to promote a feeling of psychological safety. I approach this need by reminding myself that people are only animals. Most mammals can delay the onset of labour until they're somewhere safe, so mimicking that safe environment can be very effective: you need to be able to hide under a bush in the dark, as it were. This is true even for the modern hospital setting, where I see so many patients who need to come in and physically get under the duvet in order to let go and have a baby. It is a reminder for me that we are not always as evolved as we like to think. We respond to and are affected by our environments.

For patients in the Labour Ward, safety is about things they expect from home. They appreciate having control over their environment by being able to control light levels and temperature. They want the psychological safety of knowing that they will not be 'attacked' by shiny silver and cold steel instruments. This can be achieved by including symbols of home. This element of control and psychological safety has been studied enough to be reviewed by Cochrane, a charity widely recognised for its compilations of authoritative research. They found that research overwhelmingly points to the benefits of non-institutional care for birthing, using the environment and care model. This might suggest women should simply give birth at home. However, the advantage of our care is that we are still a hospital, with access to the very best medical expertise and equipment. Balanced with a home-like care environment, pregnant mothers in our birth centre can expect the best holistic care possible.

And so, we create a 'normal' environment in a place that might otherwise be very medicalised and scary – more scary, actually, than the birth itself. In the late 1990s, CW+ (then called Chelsea and Westminster Arts) transformed our labour and delivery room from this medicalised environment to a space that offers psychological safety. A screen installation was commissioned and installed without interfering with the normal medical function of the room. Calming colour palettes were chosen, focusing on natural schemes. One side was warm and earthy, with red, orange and brown colours evoking a campfire or sunset. The other side used cool, watery blues and greens. In addition, natural textures were highlighted, with an ash wood frame curving towards the ceiling. The project included audible and social elements by commissioning live musicians for the post-natal wards.

Thinking about environment and art more broadly than a picture on the wall encourages us to look at our healthcare environment through a different lens. This lens prevents us from going down the trodden path, recreating a highly medicalised environment solely because that's what we know – the model of healthcare that I am used to. In obstetrics, we resort to therapies for pain that include drugs, cognitive behavioural therapies, and even things like electrical nerve stimulation. When we were brought these new environmental designs, we realised we could look at our procedures in a completely different way. Previously, we could do everything we needed to do medically, but nothing beyond. It was very much a clinical, old-fashioned labour ward. This adaptable, home-like birthing unit is a recent development, a result of working with the art and design team at CW+.

THE THOUGHT MATTERS

Earlier this year, the hospital had visitors from NHS England. As I showed them around, they said, 'Well, aren't you lucky. You've got such a nice estate.' I tried my best to accept the comment graciously, but I could not help thinking, 'It's not luck!' We work really hard for this. We work hard to maintain and improve our public and clinical spaces, bringing art to the environment and making activities available to patients. We give it a lot of thought.

Although it is hard work, our people are keen to do it. When we first moved into this hospital twenty-six years ago, I remember people getting funny about the art, not understanding why it was necessary to have artworks in a hospital. Well, I haven't heard that for twenty years; nobody says that anymore, after experiencing it and getting to know the rich body of research we and others are building around environment and activities in hospitals. Art installations have interacted with the building to produce a space that the community and hospital staff have rallied around. A space that facilitates a high quality of care for all patients. A space people have an emotional connection to, through conversation and contemplation. It has reframed the way I think about my practice as a physician and medical director.

4 ART AT THE HEART OF HEALTHCARE
LEWIS KHAN

In 2016-17, Lewis Khan undertook a photographic residency with CW+ at Chelsea and Westminster Hospital. Shadowing and spending time in different departments and with different staff members, Lewis has created a photographic essay of our NHS today.

A web of associations based around the universal human qualities of strength and fragility, using this diametric as an entry point for framing work that looks beyond the conventionally mediated hospital image – the simplistic, or the sensational – and penetrates deeply, past stereotypes, into some of the fundamental themes running through healthcare and its environment, such as mortality and wellbeing. The hospital environment is one in which the protections of day-to-day life are peeled back, and vulnerability and care are encountered as very visceral elements to the human condition.

Complex reciprocal relationships of care also challenge conventional ideas around power and status.

The project is situated in the context of the contemporary landscape of UK healthcare; the privatisation of the NHS, and there is allegorical connection between the immediate themes explored in the project and the unfolding wider political situation.

Lewis Khan, Photographer in Residence, Chelsea and Westminster Hospital

5 ON BEING A MUSICIAN
AT CHELSEA AND WESTMINSTER HOSPITAL
DR ANDREW HALL

As I was setting up a music group session on one of the hospital's wards for older adults, a Spanish woman was brought in in a wheelchair. The ward manager had told me she was quite confused, and that she also didn't speak much English, so communication might be difficult. The woman asked me what city she was in and when I told her she seemed disappointed, replying that her husband had passed away at a hospital in Madrid. As we talked further this same exchange was repeated several times, clearly at the forefront of her mind, so I moved to the piano hoping that music might prove a distraction.

As more patients entered the room I encouraged them to help themselves to one of the percussion instruments on the table while I continued to play and quickly we formed a small band. The Spanish woman, who had yet to respond to the music, tentatively picked up a shaker and began to turn it over in her hands. As she found a rhythm I began to copy her, letting her movements dictate the tempo of the music: she quickly became transfixed with the shaker and the pulse we'd created. The ward manager took a xylophone over to her and handed her a stick, and she immediately began improvising a melody over my piano chords. As the music came to a natural end, and we all gave ourselves a round of applause, the Spanish woman looked up at me from her xylophone, and, with a broad smile, exclaimed, 'I can't believe it!'

I OFTEN think that 'hospital' is not an adequate word to describe Chelsea and Westminster. It's too simple to reflect that space, comprised not only of wards and treatment areas but also galleries, concert spaces and gardens. Fittingly, one of the first things you might notice when walking into the hospital is the phrase, 'The Healing Arts', carved into a sculpture by Eduardo Paolozzi. Continue into the building and you will no doubt be struck by the scale of the huge atrium, bathed in natural light and clad with chrome and glass, feeling akin to a shopping centre or airport terminal. You'll notice the buzz of activity, a vibrant ecosystem formed by thousands of staff, patients and visitors, giving the building its own distinctive diurnal cycle.

But you also can't fail to notice the scale and presence of the arts: whether it's the silver orbs of *Assembly/450* by Joy Gerrard, the towering *Acrobat* by Allen Jones, or one of the many lunchtime performances organised by the hospital charity, CW+, it quickly becomes apparent that this is no ordinary hospital.

1. A ballet performance in the 1990s, Chelsea and Westminster Hospital Photo: CW+

This was my experience of first entering Chelsea and Westminster Hospital almost three years ago, following my appointment to CW+ as a 'musician in residence'. Arriving as a recently graduated PhD student, and never having worked in a healthcare setting, it's safe to say I was not prepared for either the vibrancy or complexity of the area of work I was entering.

In my first weeks in the role, I was awestruck by the degree to which the arts were embedded within the hospital: not only the gallery-like walkways, or the fact that there is a full-scale cinema within the building, but also the charity's close links to nearby cultural institutions such as the Royal College of Music and Opera Holland Park, who frequently bring performers to the building's wards and treatment spaces.

Such performances form part of a rich and varied programme of performing arts and participation events for patients, happening on a nearly daily basis across many

2,3. **L to R**. A Rambert dance class, Ron Johnson Ward, Chelsea and Westminster Hospital. Photo: Ben Langdon/CW+
4. Akademi dancer performing on one of the wards for older people, Chelsea and Westminster Hospital. Photo: Akademi

different parts of the hospital, and are by no means limited to music. Other regular activities include dance performances and workshops, with dancers from Rambert, Akademi and the Twin Swing duo, not to mention gardening workshops, show-and-tell sessions, with objects brought from museums around London, and even visits from therapy dogs. Furthermore, I quickly discovered that my new role in this programme was a continuation in a long line of previous commissions and partnerships with individual artists, including, in 2014, the commissioning of fifteen composers to write pieces to accompany the hospital's art tour (becoming a CD and app known

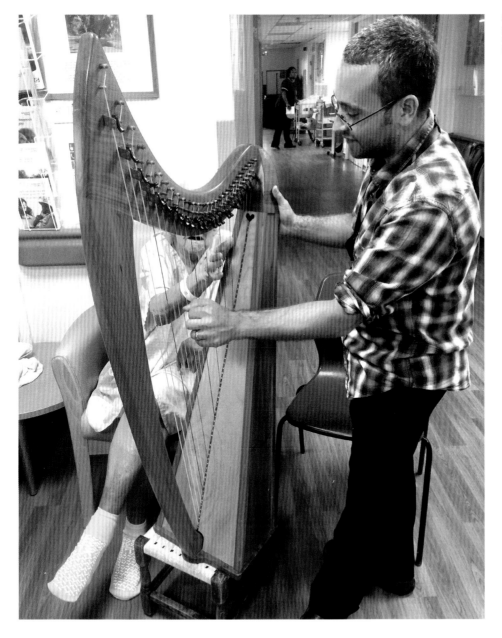

5. Harpist Mark Levin working with patients on the wards, Chelsea and Westminster Hospital. Photo: CW+

6. A pianist playing during a
lunchtime concert,
Chelsea and Westminster Hospital.
Photo: Ben Langdon/CW+

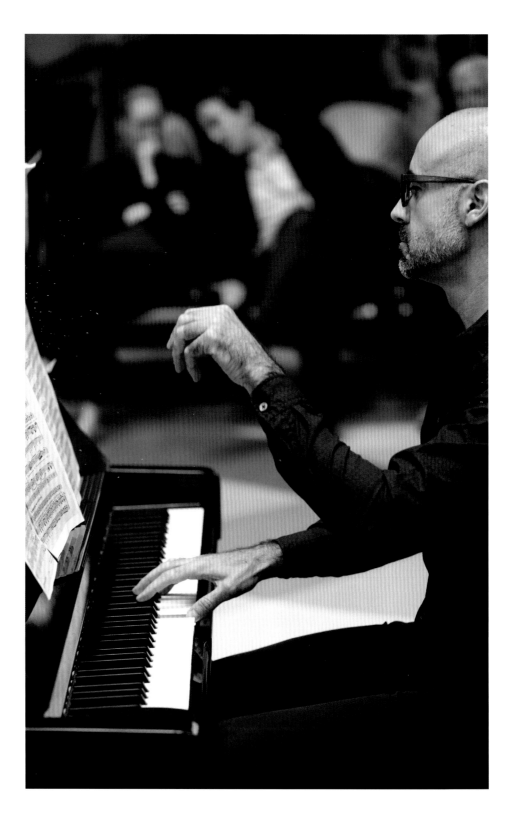

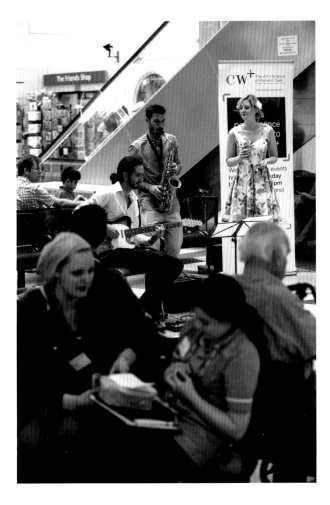

7. Camino Sonoro, lunchtime concert, Chelsea and Westminster Hospital. Photo: Ben Langdon/CW+

as Rhapsody), and several commissions for visual art from Brian Eno.

As I was guided around the hospital in those early days, I began to realise the extent to which recorded sound and music featured in the design of the hospital's newest spaces: the recently completed emergency department boasted a vast sound system installed in almost every waiting area and treatment room, and the Edgar Horne Ward (one of the five wards that focuses on the care of older patients) also featured a newly installed speaker system that could stream a huge variety of internet radio stations to different bays and side rooms. Later in my time with CW+, I would help to install a sound system in the entry corridor for the intensive care unit, a place where many visitors and family members of those on the unit would wait: I will not quickly forget the sense of peace created by the combination of the fifth-floor views across West London and the steady calmness of slow piano movements by Mozart, Clementi and Haydn.

Such was my introduction to the world of music in hospitals and, in a wider sense, the movement known as 'Arts in Health'. This is a rapidly expanding field of interest for artists, clinicians and researchers, bringing together perspectives from multiple disciplines to shape a range of practices which can be broadly described as participatory, creative and, to some extent, therapeutic. The increasing abundance and variety of practice in this area is perhaps best represented by the publication of a report in 2017 entitled Creative Health: The Arts for Health and Wellbeing, authored by the All-Party Parliamentary Group on Arts, Health and Wellbeing. Throughout this report, music is shown to be a key component of participatory work, offering numerous physical, mental and social benefits for patient groups of all ages.

As many researchers have shown, the concept of music having a therapeutic effect is not a new one. In 1944, B. Bellamy Gardner's article 'Therapeutic Qualities

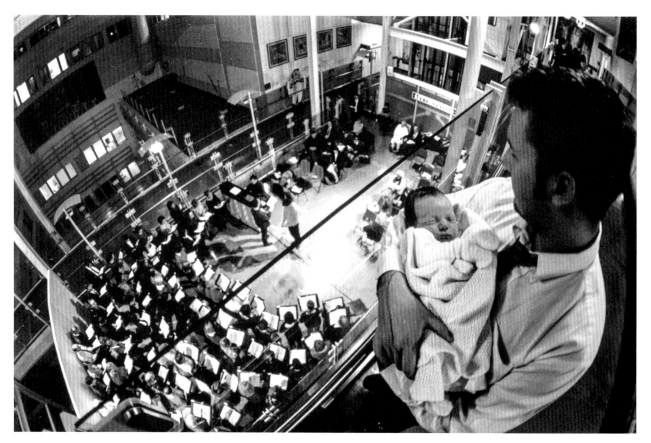

8. Performance in the 1990s, Chelsea and Westminster Hospital. Photo: CW+

of Music' examined references from antiquity on the effect of music on the human body, citing an ancient Egyptian papyrus from 2500 BC as the earliest written account. Music therapist Jane Edwards wrote in detail in a 2008 article about the uses of music in healthcare in the late nineteenth and early twentieth centuries, beginning with Frederick Harford's Guild of St Cecilia, formed in 1891 to play music to hospital patients in London. Music is also mentioned by Florence Nightingale in her 1859 text 'Notes on nursing: what it is, and what it is not', in which she even goes into detail as to which instruments she believes are most soothing for patients.

It was a ward performance by a group of singers from Opera Holland Park which gave me one of the most memorable moments of my early days at Chelsea and Westminster. The singers were visiting bays on several different wards to sing songs requested by patients. These were a mixture of classical arias ('The Flower Duet', the 'Habanera' from Carmen) and show tunes ('A Nightingale Sang in Berkeley Square', 'Edelweiss'), each accompanied on a wheeled Clavinova piano that could easily be moved from one bay to the next. The impact of the operatic voices on the patients was immediate and seismic: heads were quickly raised to the spectacle that was taking place by their bedsides, and faces lit up in recognition of the music. The presence of the performers created an extraordinary atmosphere, a sensational musical encounter

that was much more about spectacle than simple reminiscence; a brief window out to a resplendent operatic world. The sound was so potent that when the performance ended one patient with dementia asked, 'Who turned the lights out?'

Music at Chelsea and Westminster Hospital dates back to 1995, when the hospital became the first in the country to host weekly live performances. Since then the regular lunchtime concert series has continued to be the flagship event of the CW+ performing arts programme, with a vast array of artists visiting the hospital to perform in styles as diverse as classical, jazz, rock and roll, world music and folk. Relationships with local arts institutions such as the Concordia Foundation and Akademi have helped to maintain a consistently high quality of performances throughout the year, and the concert series has now developed a dedicated audience of its own who attend regardless of whether they have a need to visit the hospital.

Every weekly concert is followed by a performance on one or more of the hospital's wards, leading to some of the most memorable musical encounters in the hospital. Notably, in recent times these have included: patients waiting in the hospital's transport lounge being serenaded by an ancient 'theorbo' (a huge bass lute), children in paediatrics getting to play on a full-size orchestral harp, and Happy Birthday being sung to a ninety-year-old woman by a 1950s-style crooner. These performances form just one part of the wider programme of music-making which happens on the hospital's wards each week: in addition, the hospital's pianist, violinist and harpist in residence (Maria Marchant, Adrian Garrett and Mark Levin respectively) make

9. Staff and patients sing together during a ward-based 'Memory Lane' sing-along with a pianist, Chelsea and Westminster Hospital. Photo: Ben Langdon/CW+

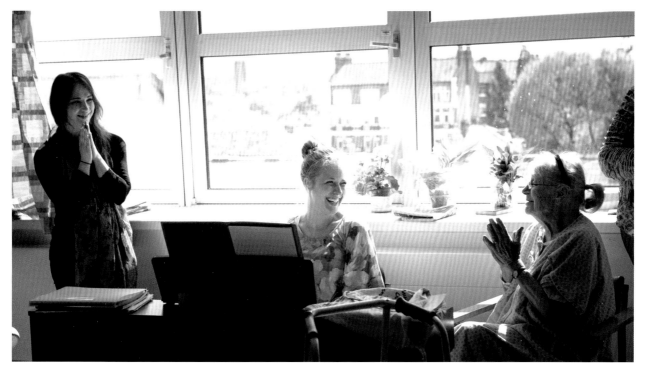

weekly visits to perform for patients of all ages, while charities such as Music in Hospitals collaborate with CW+ to provide one-off ward performances on a regular basis. Participatory music-making groups have also become an important part of the musical life of the hospital, whether it's the seasonal camaraderie of the staff Christmas choir, the pub-style ward sing-alongs led by singing leader Natasha Lohan, or my own weekly percussion group held on the hospital's stroke specialist ward.

The benefits of this diverse programme of live music, participatory activities and ambient sound installations may seem obvious to many: a pleasant distraction for patients, moments of respite for visitors, and a lightening of the working atmosphere for staff, to name just a few. Perhaps my most significant realisation from working in a healthcare setting, however, was how challenging it would be to fully capture and communicate this impact: perhaps naively, as a working musician I simply wasn't prepared for the idea that anyone would ever need to have these benefits proven. In this regard, Jane Edwards's 2008 article is particularly interesting for highlighting some of the historical criticism levelled at what was sometimes mockingly called 'medicinal music'. For example, in response to Harford's 1891 proposals for live music in hospitals, the editor of the *Lancet* wrote, 'It must be remembered that the function of this pleasing art is in most cases quite subsidiary, and its effects are merely temporary.'

While it is undeniable that attitudes towards the role of the arts in healthcare have changed a great deal since this time, as evidenced by the aforementioned APPG report, it is still the case that, as the introduction to that report states, 'Received wisdom has yet to recognise consistently that the arts can help to humanise the system, not just as a nice add-on but in complementing and enhancing the effectiveness of conventional medicine.' Arts practitioners working in this field must therefore seek ways to demonstrate the efficacy of their work, and a variety of different qualitative and quantitative evaluation methods are used to this end, ranging from personal stories, photography and video, to randomised controlled trials using clinically validated measurement tools.

Working with the clinicians of Chelsea and Westminster Hospital, researchers at CW+ have played an important role in developing the evidence base for arts interventions in acute healthcare settings. From 1999 to 2002, Rosalia Staricoff led pioneering research projects at the hospital examining the benefits of visual and performing arts for patients, and went on to publish major literature reviews in 2004 and 2011. A collaboration with the Royal College of Music's Centre for Performance Science has also yielded important research in this area, such as an examination of the benefits of singing for new mothers at risk from postnatal depression, and an evaluation of the efficacy of participatory groups for older patients that incorporate new digital technologies.

Some of my most memorable ward-based musical moments came from a joint project I undertook with the extraordinary singing leader Natasha Lohan. Over two months, we visited the hospital's Rainsford Mowlem Ward on a weekly basis, with the aim of instigating a relaxed 'sing-along' session within each bay. Natasha is a master of making a collective social activity feel personal to each participant, surely one of the

greatest challenges for a singing leader in this setting. One patient, a woman from Sierra Leone, watched our weekly visits from her bed, seeming to enjoy the music but not obviously wanting to engage further. On our fourth visit to her particular bay, she began to take a deeper interest as we all learned a song taught to us by one of the patients. As we listened, I picked out an accompaniment on the piano, and Natasha began to teach the song. We handed out some tuned percussion, forming a small band within the bay, and soon we attracted a crowd of clinical staff. As our improvisation came to an end there was an enthusiastic round of applause, followed by a moment of silence – and then, out of nowhere, came the clear singing voice of the woman from Sierra Leone. The bay was still as she sang – Natasha and I glancing at each other in astonishment – and when she finished, there was another rapturous round of applause. When asked what the song was, the lady simply described it as 'a song from home'.

Through my own work with CW+ I have come to see there is great complexity in the impact that music has in this setting, and the challenge this presents has significantly reshaped my own practice as a musician. As an example, I return to my early days of working at Chelsea and Westminster and my first attempts to grapple

10. Emili Aström sits with a patient for a bedside music listening session, Chelsea and Westminster Hospital. Photo: Lewis Khan

with this new world of music in healthcare. Having trained as an experimental musician, steeped in the uncompromising ideologies of post-war modernism, the idea of music as inherently relaxing or therapeutic was difficult for me to engage with. The very nature of music is rooted in tension and release, be it through the tonal structures of western classical music, the polyrhythmic complexities of Indian raga or the burning momentum of a Hendrix guitar solo. How, then, can music be fundamentally 'relaxing', given that its appeal also necessitates the development of tension?

This question was given added urgency when I was asked to consider what music could be installed on the new emergency department sound system, replacing the playlist of piano pieces by Ludovico Einaudi and Yiruma (two popular pianists whose music is frequently characterised as inherently 'relaxing'). I considered solutions to this

11. Andrew Hall leading a participatory music group on one of the wards for older people, Chelsea and Westminster Hospital. Photo: Ben Langdon/CW+

problem from compositional and analytical viewpoints, hypothesising that listeners in waiting areas would not benefit from the minimalist approach of Einaudi and his stylistic fellows, as the cycling modality of the pieces could arguably leave patients with a feeling of stasis or immobility – not a welcome feeling if you've been waiting for several hours. Instead, my new playlist turned to the 'classical' era of western classical music, which runs roughly from 1750–1800, and includes the likes of Haydn and

Mozart. The music from this period is characterised by order, symmetry and balance: what better music to listen to while waiting than a style which leads the listener through a carefully measured and balanced tonal journey, culminating in a perfectly satisfying outcome?

Despite the feedback on my playlist updates being mostly positive, there were certain comments that I found surprising. One clinician referred to the style I had chosen as 'music for a funeral', another described it as 'spa music', while others simply commented that it was not a style they thought their patients would enjoy. Through these and similar comments, I began to realise that, with my focus on musical content, I had fallen into the same trap as much of the research literature on 'relaxing music': I did not take into account the enormous complexity of how musical meaning is created, and the vast web of cultural associations that leave the identification of any single meaning or purpose impossible. The innate subjectivity of musical semiotics is, arguably, one of the characteristics that keeps us listening. In this regard, it is worth quoting at length the music analyst Kofi Agawu, who writes:

> As long as music is made, as long as it retains its essence as a performed art, its significance is unlikely to ever crystallise into a stable set of meanings that can be frozen, packaged, and preserved for later generations. Indeed, it would be a profoundly sad occasion if our ideologies became aligned in such a way that they produced identical narratives about musical works.

The complexity of the challenge that presented itself was an anxiety-inducing wake-up call to a musician who had spent much of his life in academia. It led me to wonder: What had my training been for? Was the skill that I had studied really needed in this setting, or any setting other than concert venues or lecture theatres? I shared these thoughts with a visiting musician and academic, who suggested it was comparable to a shift of perspective from modernism to postmodernism: the former relies on received wisdom from academic or 'high-culture' sources, while the latter places emphasis on complexity, diversity and choice. In the hospital context, it was the classification of 'relaxing music' which I believed had been subject to questionable received wisdom: I had always found the majority of empirical research in this area to be overly simplistic in musical terms. But when my own theory of focusing on 'Classical' era music had proven equally insufficient in practice, a fresh consideration of the problem from a 'postmodern' perspective seemed increasingly appropriate.

Instead of belief in a rational or empirical solution to this challenge, I needed an approach that put power in the hands of service users. Such a shift would also bring the added benefit of giving control to patients in an environment which might be considered to be characteristically disempowering. Interestingly, I began to see the parallels in this to 'person-centred' and 'holistic' models of care within the healthcare profession. Indeed, writers such as Philip Lister have discussed a postmodern model of nursing, in which there is 'a move to increase client choice and even control. … Nurses would increasingly be able to use their professional power to empower their clients, rather than use power on their behalf in a parentalistic way.'

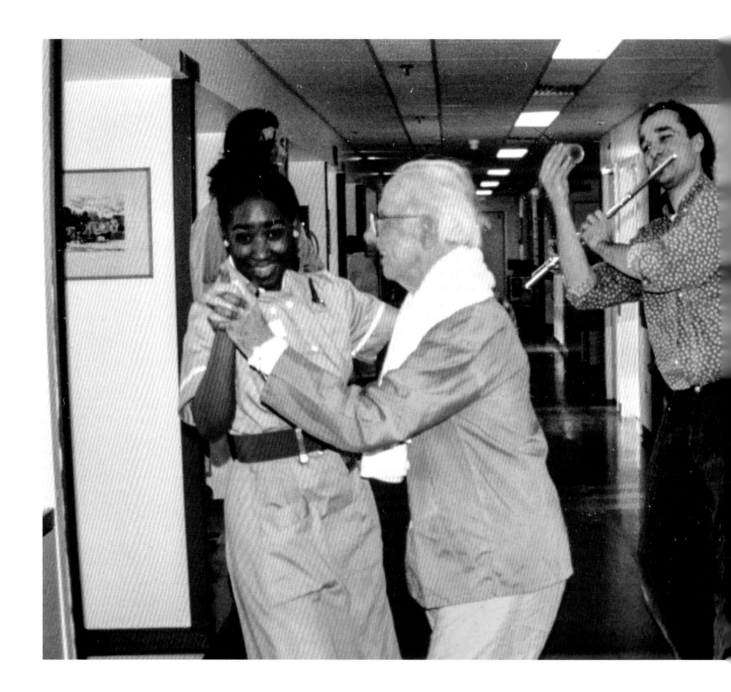

12. Music and dancing on the wards
in the 1990s.
Photo: CW+

It's not surprising, perhaps, that many younger patients expect choice when it comes to music listening, given the impact of the internet and streaming services on the way music is now consumed. However, with older patient groups, particularly those living with dementia or other forms of memory loss, the immense resources available online can be used to remarkable effect. A striking example of this occurred during a bedside music listening session on one of the hospital's dementia specialist wards. I sat down

118

with a man who explained how he had grown up listening to jazz on the radio, but his memory was such that he couldn't remember many details. I fired up the tablet and Bluetooth speaker, and, being a jazz fan myself, chose some of the classics to get us started: Count Basie, Louis Armstrong, Ella Fitzgerald and so on. Soon he remembered that he particularly liked Dave Brubeck, so that went on the playlist next. Suddenly he leaned forward and, with a furrowed brow, began to recall the title of the radio show he had loved – the Voice of America Jazz Hour. He even recalled the deep baritone voice of the presenter. A quick online search led me to a video of the show's introduction by its presenter, Willis Conover, and as it played, the patient's face lit up in recognition and astonishment: 'This is it! I can't believe it!' He sat back, staring into the distance with a beaming smile as we listened to the show's theme tune: Duke Ellington's 'Take the A Train'.

This emphasis on empowerment through choice and participation is at the centre of the music and performing arts programme, which CW+ now delivers for both Chelsea and Westminster and West Middlesex hospitals. In the emergency department there are now eight different playlists to choose from, with every clinician and patient able to select the style of music that plays in a particular treatment area, and any new sound system installations in the hospital are similarly equipped. For inpatients, the foremost opportunity for artistic engagement is through the regular participatory group sessions that operate on the paediatric and older people wards. Whether the medium is art, craft, gardening or music-making, patients are invited not only to witness these artforms but also to become actively involved, even dictating the structure and subject matter of a workshop. My own weekly percussion group has become a useful setting in which to explore the participation of patients with even the most severe of symptoms: this might range from simply requesting a song to be played, to full performative engagement using a variety of shakers, drums and xylophones. The success of this group rests on the founding musical principles of flexibility, improvisation and choice. This success is mirrored in the practice of the hospital's other resident musicians, who are equally adept at thinking on their feet to provide patients with a deeply significant and meaningful musical experience.

Where group participation is complicated by a factor in the patient's medical care, innovative solutions are sought, often incorporating new technologies. Examples include various bedside activities, which can reach patients who are unable to move to a day room for a group workshop: my development of a mobile app called OPRA – the 'Older People's Rhythm App' – was a response to this challenge, and affords bed-bound patients a sense of musical engagement through simple touchscreen interfaces.

Technology has also transformed bedside music listening sessions, with streaming services allowing for a near-infinite choice of music for patients to request. This choice has proven particularly effective for patients from other countries and cultures, and I've had some wonderfully informative listening sessions with music enthusiasts from around the world. Advanced music technologies further enable choice in areas where music might be crucial to specific patient outcomes: the 'Pulse Music' system I developed for the hospital enables clinicians to adapt the tempo of patient-selected music in response to the listening patient's heart rate, combining patient choice with clinical intervention.

In this way, working for CW+ at Chelsea and Westminster Hospital has transformed me as a musician. I arrived with grand designs and aspirations, fully believing that my compositional or technological training would offer a solution to the great challenges of music in healthcare. I now realise that these aspirations were as much about my own desire for affirmation as they were about helping patients. The hospital environment does not require a composer, not when a decent radio will do the job. But it does still require creative thinking: How can we most effectively use music and sound interventions to empower patients, and return to them a sense of control, which can be so quickly lost in acute settings? How can new music technology enable participation for patients whose symptoms may leave them excluded from traditional participatory activities? These are the kind of questions I now focus on in my work at working for CW+ and with the generosity and warmth of its staff, and the enormous courage of its patients, it is impossible not to feel a great deal of excitement for the future role of music in this unique and inspiring hospital.

6 DRAWING IN THE HOSPITAL
ANOUK MERCIER

I had started to take the power of drawing for granted. This is easy to do when working from the privacy of one's own studio. Pencils adopt the comfortable familiarity of old friends: they are always present, scattered on desks in various states of sharpening, or found at the bottom of bags and in coat pockets. During busy periods of production, pencils even inform the shape of fingers for weeks at a time. Paper, on the other hand, becomes a terrain well-loved and travelled: smells, colours and textures as familiar as those of a favourite walk.

We had been intertwined, my pencils, paper and I, for many years in a well-rehearsed but very private dance, whose ultimate purpose was to capture and fabricate landscape through painstakingly detailed drawings. The invitation to become Drawer in Residence for CW+ at Chelsea and Westminster Hospital provided me with a unique opportunity to question, challenge and ultimately broaden this life-long relationship with drawing.

1. Anouk Mercier (b. 1984), *And the Sun Slowly Illuminated the Plain*, 2014. Acetone transfer, toner, airbrushed inks and graphite on paper, 100 x 46 cm. Chelsea and Westminster Hospital. Photo: Max McClure

121

IN THE BEGINNING

I vividly remember the first time I took out a pencil and sketchbook at Chelsea and Westminster Hospital. More to the point, I remember how acutely aware I felt reaching into my bag and retrieving a pencil; an action familiar and repetitive enough to have become automated yet, in this new context, suddenly loaded with new possibilities and potential consequences. It had been suggested that accompanying Eli the storyteller on his round of the Lord Wigram Ward, for patients recovering from strokes, would be a good way for me to start my year-long residency. A storyteller, as it turns out, is someone who has incredible talent for encouraging others to tell their own stories, to tease out the most extraordinary, ordinary narratives. As I sat and listened to the woman who had immigrated to London in the 1930s and survived unimaginable racism, the man who had lost everything and found himself living on the streets and celebrated the freedom he found there, the woman whose partner had burned her in an acid attack and gone to prison, or the daughter whose mother had immigrated from Italy in the 1950s and cooked the most incredible Italian meals, I seriously questioned whether I could draw anything that would record and support the beauty and power of their words.

I also felt nervous to break the spell that seemed to have been created between Eli and each of the patients he spoke to. I realised that this relationship was built on a great deal of trust and support, and that both of these were achieved through body language, tone and, perhaps most importantly, eye contact. Drawing involves some degree of looking down at the surface onto which the drawing is carried out, and looking away from the narrator in this context felt inappropriate and counter-intuitive. Yet, keen to establish my role and prove that I could in fact draw, I eventually did reach into my bag for my pencil. The anticipated effect was immediate: the patient who had been talking about her abusive partner stopped abruptly and started re-arranging her hair.

This reaction was a very real reminder of a drawing's primary function as a tool for recording, and as such, of its power to make people feel self-conscious and vulnerable. It taught me that some of the events, conversations and fragilities observed in the hospital setting cannot, or will not, easily be pinned down through pictorial representation.

Yet I quickly realised that if being recorded through drawing brought vulnerability to some, it also empowered others. To be drawn implies that one is a worthy subject; one that the artist has chosen to capture. Being studied and observed may be unnerving but it forces a subject to reevaluate what he or she has to offer, both pictorially and conceptually. 'Why me? Why here?' became my favourite questions to answer. I enjoyed explaining to Martin Harrington, the fabrics and extra works supervisor, about the incredible linear propositions the plant room had to offer, and watching his perplexion when I asked to see the wiring systems hidden behind a concertina door in one of the main hospital corridors. I enjoyed the intrigued surprise of anaesthetist Andrea Weigert, when I shared my passion for paper and excitedly commented on the quadrille yellow paper reserved for the recording of anaesthesia notes. I enjoyed the pride of a patient and his partner who found it amusing that I had chosen to capture their impeccable style as they sat through a difficult consultation.

I realised that through my drawing, I was offering perspective, a fresh pair of eyes, on situations and contexts that were either incredibly familiar or totally unfamiliar to the protagonists involved; recording both the extraordinary qualities of some of the most ordinary aspects of hospital life, as well as capturing the banality of extreme situations and ultimately giving equal value to both.

Invariably, however, I would explain that artists are curious people and that drawing is a means of learning and therefore satisfying that curiosity. And never was this truer than during my residency at Chelsea and Westminster Hospital. Hospitals are both familiar and enigmatic places: we have all interacted with them at some point, though often as temporary visitors, fleeting through. They are places of comfort and also of fear: people get better or worse within their walls. These contradictions have ensured hospitals remain mysterious institutions: we are curious to know what goes on behind the scenes, but we fear what might be revealed. We are unlikely to interact with in it any other capacity than as a place to enter when we or a loved one is unwell, and hope to leave promptly, and healed. Being invited in as part of the CW+ Drawn in Residence programme presented me with an alternative proposition: spending prolonged periods of time within a hospital environment without the prerequisite of ill health; with sound mind and body, to explore, question and respond to the interworking of a sacred institution through art, led only by my insatiable curiosity.

DRAWING AS A CONVERSATION STARTER

The notion that any door within the hospital could theoretically be opened to me was initially overwhelming. In an era during which new terrorism laws have made it compulsory to get permission to draw in public spaces, and access to sensitive areas is often restricted, such willingness to collaborate with an artist was both surprising and refreshing. At first, navigating the complexity of the hospital building itself, and that of the staffing structures and specialisms, was challenging, as was managing people's expectations of me. Just as I had preconceived ideas regarding the roles of hospital staff, so, too, did they and the patients have preconceived ideas of what a drawing artist is. After declining several requests to draw portraits, scribe notes for meetings or illustrate brochures, I realised that I needed to define 'an approach': a way of interacting with people that did not solely involve me drawing them at work. I was keen to establish a dialogue – a way of building a reciprocal relationship between myself and those I drew – that would result in both parties gaining a better understanding of the other. I decided to start by asking staff to talk to me about their relationship to drawing.

One of the most powerful qualities of drawing is that we have all engaged with it as children. This means that, unlike other mediums, there is a basic universal understanding of the act of drawing itself: most people can relate to holding a pencil and making a mark with it. This offers a wonderful opportunity for common ground. By prompting staff to discuss drawing, I hoped to override any preconceived ideas about roles or agendas by focusing on a shared experience.

Perhaps the best way of illustrating how this worked is through recalling my first meeting with Martin, the fabrics and extra works supervisor previously mentioned.

After a couple of weeks of trying via email to explain my role as artist-in-residence and why I would like to meet with him, Martin and I finally came face-to-face one morning in the hospital. I waited for him on a bench in the atrium and, as he sat down and shook my hand, he said something along the lines of, 'Nice to meet you but I don't think my area will be relevant to you and I don't really know anything about drawing.' It struck me, as he sat down next to me, that tucked behind his right ear was … a pencil. I questioned him about it and he replied, 'Oh, that. I always carry it with me – it's a quick way of taking notes and drawing diagrams.'

This opening exchange was followed by a two-hour-long tour of the hospital's key facilities hubs: heating systems, cooling systems, lift shafts, electrical circuits, to list a few. Martin discussed with great detail and passion the challenges and logistics of overseeing such a sizeable structure. He also ran through the complex visual coding systems used to clearly identify areas, and showed me the latest software developed to oversee the hospital's two plants. I would later find out that minor physical alterations to these systems, such as a change in wiring, are often recorded in drawing form and stored as such until they are inputted into the 'mother' software systems every five years. Both the tour and Martin were fascinating, but my favourite moment came towards the end when he talked to me about his passion for wood carving and showed me examples of his beautiful work on his phone. We finished by talking about mark making and creativity; a conversation we may not have had had we not started by discussing a shared understanding of pencils.

DRAWING AND DIGITALISATION

And so, discussing drawing became a starting point to most of my interactions with hospital staff. I was intrigued to discover that most staff I met nurtured a creative practice outside of work: there was Katey Hewitt, the pharmacist, who was taking drawing classes and asked me for some drawing exercises for her daughters, Andrea, the anaesthetist, who was an accomplished stained glass artist (among other things), and Mark Bower, the doctor, who collected art, to name a few. However, what quickly became apparent was that discussing drawing with hospital staff was more relevant to their practice of medicine than I had initially anticipated. Far from a simple conversation opener, this subject, I realised, was pertinent and one that merited discussion: in light of fast-moving digitalisation across all hospital areas, the relevance of drawing as a tool for recording and communicating was under review.

Drawing, and mark making more widely, has always played an important role in the recording and transcribing of medical notes and ailments. While this role diminished with the advancement of technology and introduction of photography and various scanning technologies, it is still present: surgeons still carry out post-operative drawings to record procedures, anaesthetists use coded diagrams and simplified forms to indicate location of surgeries on the body and hand draw fluctuating patient parameters during operations, and doctors draw diagrams during morning clinics to illustrate the advancement of tumours or how the body reacts to a miscarriage. Drawing is still seen as a quick and effective way of communicating and recording important information. Yet a drawing or mark can be inaccurate, misspelled, misread

and ultimately misinterpreted and for that reason, it is flawed. Digitalisation seems, therefore, a logical answer, and welcome solution, for reducing the risk of basic human error. Doctors notes are now either scanned and filed, or typed up digitally by a designated team. Robots input, store and output medication in the pharmacy. Anaesthesia machines are being replaced by new versions that will no longer require anaesthetists to record patients' observations by hand. These advancements, undoubtedly, have made hospitals safer, but they have also had unforeseen consequences on the day-to-day life of hospital staff, as well as unexpected setbacks.

2. *Hospital Whiteboard (I)*, 2018.
Chelsea and Westminster
Hospital.
Photo: Anouk Mercier

This complex situation was best illustrated during a morning spent shadowing Professor Mark Bower in the National Centre for HIV Malignancy Clinic. Atypically, Mark invited me into his department. I spent time in the professor's consultation room, meeting and talking to patients, while observing and recording consultations through drawing. It was a challenging proposition due to the intimate proportions of the space, and the serious, at times life-changing, nature of the conversations held within it. Once again I questioned the intrusiveness of the act of drawing patients, and faced the anxiety of heightening their existing vulnerability. Once again I brought up drawing with Mark as a means of opening up discussion and buying myself time, while I worked out how best to record the scenes before me. Once again, I was surprised by the relevance of discussing drawing and mark making within the context of medical practice.

Drawing, as it turned out, was still very much at the heart of Mark's practice: an essential tool for recording and monitoring the progress of patients' tumours. I watched as he drew the retracting lesions of a patient's skin cancer, comparing his drawing to the one he had drawn of the very same lesions a few weeks prior. I asked why he chose to use drawing over photography; after all, the hospital was equipped with its own Medical Illustration (soon to be renamed Medical Photography) Department to serve that very purpose. Mark explained that sending patients down to Medical Illustration had both cost and time implications and as a result, was not always an available and viable option. He also explained that until very recently, doctors would use the cameras on their phones to record and monitor tumours, but that due to the recent adoption of the GDPR (General Data Protection Regulation) laws, this was no longer an option. Having used their own cameras for years, doctors in his department were now faced with having to use either the written word or drawing to record their observations.

Of course, this called into question the reliability of drawing as an accurate tool, not only for recording, but also communicating: one doctor may interpret another's drawing very differently to how it may have been intended. A drawing offers room for interpretation in a way that a photograph does not, and this potential fallibility did not escape the patients whose ailments were being recorded. One patient was obviously concerned that the tumours on his feet were not being documented photographically, and was visibly distressed about it when I spoke to him in the waiting room following his consultation. Yet there are cases when drawing offers something that photography cannot. Midway through the day, Mark introduced me to a patient who was afflicted with a tumour in his neck. Although this tumour was significant in size, it was nearly invisible to the naked eye, and therefore difficult to document through photography. Instead, Mark drew what he felt. And he encouraged me to do the same: with the patient's permission, I too felt the tumour and queried how best to draw it. This was one of the most powerful moments of my residency at Chelsea and Westminster: a very concrete example of the potential of drawing as a tool for recording interpretive information, in this case of translating a sensory experience into a visual archive. The same subjective quality that meant drawing was fundamentally flawed as an accurate method of recording, also made it a unique tool for transcribing (sensory) experiences and documenting a doctor's very personal interpretation and understanding of

ISSUES WITH BALANCE ...

3. Anouk Mercier,
Patients' Hands and Feet, 2018,
sketchbook drawing recorded during
consultations with
Professor Mark Bower,
National Centre for HIV Malignancy.
Pen on paper, 19 x 25 cm.
Chelsea and Westminster Hospital.
Photo: Anouk Mercier

a developing illness.

This was one of several examples where Professor Bower felt that drawing, and mark making more generally, held its own in contemporary medical practice and deserved to co-habit alongside new technologies. He was not alone in thinking this way: Dr Andrea Weigert, Clinical Director for anaesthetics, theatres and intensive care, shared a similar view with me during a fascinating day spent shadowing her in the paediatric operating theatre. She said their current anaesthesia machines and monitors were due to be replaced by new, state-of-the-art versions. Together with a new

4. Anouk Mercier,
Anaesthesia Machine, 2018.
Sketchbook drawing
Pen on paper, 25 x 19 cm.
Chelsea and Westminster Hospital.
Photo: Anouk Mercier

software system, this would mean that recording patient observations by hand during operations, as had been the case until now, would eventually become redundant. One possible drawback, Andrea explained, was that the automated recordings did not necessarily take context into account. For example, an abnormally high reading of a heart rate might be picked up by the monitor due to an artefact of electrical interference from a surgical instrument, when the actual heart rate was normal. On a handwritten chart, this abnormal reading would be disregarded, but on an automated printout it would be documented and require a comment or annotation to explain why there should have been these seemingly alarming readings. Machines are unable to differentiate between real and artefactual anomalies, and this might be problematic in reflecting a global representation of how a procedure went. Once again, the ability for drawing to reflect informed, curated information, rather than automatically generated facts and figures, gave it concrete relevance in a medical situation. Moreover, paper provided a secure back up, should technology fail.

If drawing prevailed in these contexts and was proving itself irreplaceable, this was not the case in many other areas of hospital life. The very act of using a pen to record information was quickly being phased out, perhaps most poignantly illustrated by the numerous blank whiteboards that could be observed throughout the hospital wards. Once hubs of information gathering and sharing, these now hung bare, replaced by more efficient and secure software programmes. These had made it quicker, easier and

safer to share information throughout the hospital. However, the digitalisation, and therefore homogenisation, of patient notes had had an unforeseen consequence on the daily act of looking through patient files. Previously, doctors had relied on recognising their own handwriting and pen colour to trace their observations in bulky paper files, at times comprising years of documented notes. Now, they had to scroll through pages of small, typed notes on computer screens, and this, some felt, had slowed them down. The uniqueness of the marks created through handwriting had also ensured mark making retained a key role in the pharmacy department, one of the most extensively digitalised environments within the hospital. Although the process of storing medication was now overseen by robots, pharmacists' signatures were still relied upon to ensure traceability and accountability.

DRAWING AS RESTORATION

Discussing drawing with hospital staff gradually became the focus of my residency at Chelsea and Westminster. Observing and questioning its relevance in the very practical context of hospital life forced me to revisit my own relationship to drawing and to the basic act of making a mark; its potential and its flaws, its power and fragility. Alongside documenting my findings and conversations with hospital staff, I felt compelled to produce a body of work that would celebrate these dichotomies.

The inspiration for doing so presented itself when reviewing the hospital archives.

Two new archivists had recently started reviewing and classifying artefacts and documents from the Chelsea and Westminster Hospital Archives. As part of my residency, I was invited to look through some of the items they had unearthed

5. Photograph of a group of nurses, 1919. Chelsea and Westminster Hospital Archives

and one in particular stood out – a photograph taken in 1919 of fifty Westminster Hospital nurses. The reason for my interest in this item was not the photograph itself, but the fact that it represented women. One of my earliest observations at Chelsea and Westminster had been how male-dominated the historical narrative of the hospital's initial creation and consequent evolution was. Several of the hospital's

6a. Anouk Mercier, *Nurse no. 15*, 2019, graphite on paper (crop), 8.2 x 11.5 cm. Chelsea and Westminster Hospital. Photo: Max McClure

extensive corridors were lined with male portraits, imposing, austere oil paintings, or sympathetic caricatures. The hospital's gold-encrusted list of significant donors and benefactors was also overwhelmingly male-dominated. And I had been struck, early on in my residency, that a talk I attended about the history of the hospital had nearly solely referred to male protagonists. There is no doubt women have played a significant

6b. Anouk Mercier,
Nurse no. 11, 2019.
Graphite on paper (crop),
8.2 x 11.5 cm.
Chelsea and Westminster Hospital.
Photo: Max McClure

role in the hospital's history: from Mrs Sherman, a midwife who agreed to lend her house to act as the hospital's first storeroom in 1716, to the numerous nurses and administrators who have served the hospital since its creation, up to the many women holding key leadership roles at Chelsea and Westminster today. Yet, the photograph in the archive was the first tangible, visual record of this female presence that I observed. Given their significance in the hospital's history, it was all the more surprising to discover that none of the women's names had been documented.

At a time when equality of women's rights in the workplace is again under debate, I felt compelled to address this lack of representation and documentation. I decided that I would painstakingly draw each of the nurses' individual portraits,

7. Hospital Whiteboard (III), 2018.
Chelsea and Westminster
Hospital.
Photo: Anouk Mercier

celebrating their uniqueness and questioning their potential personalities, histories and roles in doing so. Once completed, a selection of the drawings were framed and displayed along a hospital corridor wall as part of International Women's Day: reclaiming physical space and historical significance for women within the hospital building. The portraits would also provide a platform from which to invite members of the public, as well as Chelsea and Westminster staff alumni, to help identify each nurse in the hope of discovering, and archiving, every woman's name and identity.

This body of work would celebrate another powerful quality of drawing: its restorative power as a tool for questioning and rehabilitating a prevailing historical narrative, while also commenting on its fragility, its ability to be rubbed away and removed, to be temporary, just as the names of the nurses pictured in the photograph had been.

CONCLUDING THOUGHTS

Being Drawer in Residence at Chelsea and Westminster Hospital offered me much more than an opportunity to document hospital life through drawing. It provided me with an unexpected platform from which to question and re-evaluate a medium with which I had been at risk of becoming complacently familiar. Drawing in the hospital reminded me of the power of drawing, and the responsibility, privilege and joy of wielding a pencil. Its simplicity of use and ready availability make it an essential tool for a language of mark making that is universally familiar and understood. This very quality is what first drew me to drawing as a child, growing up in a country as a non-native speaker, unable to communicate verbally. In the hospital setting, it takes on an entirely new significance: allowing doctors to record invisible ailments, facilities managers to make quick alterations, anaesthetists to communicate key information about forthcoming surgeries effectively. Drawing is a quick, cheap and immediate way of recording and communicating personalised information, and those very virtues make it unique and challenging, if not impossible, to replace.

However, my time at Chelsea and Westminster also, perhaps reassuringly, highlighted that drawing's practical qualities are not solely responsible for its enduring presence. There is recognition, through CW+'s growing art collection, generous provision of artistic activities to patients, and willingness to interact, promote and engage with drawing, of the medium's potential to support and enhance wellbeing. Making a mark, for all that it can be useful, is also a fundamentally human act, and one that connects us all to each other. It fulfils a primal desire to express ourselves and communicate. Pens and pencils may disappear, gradually replaced by state-of-the-art software, but when they do, they are actively missed and it is debatable whether any number of new technologies will ever reverse this reality.

The discarded whiteboards scattered throughout the hospital would certainly support this proposition: their original function defunct as surfaces for the recording

8. *Hospital Whiteboard (II)*, 2018.
Chelsea and Westminster Hospital.
Photo: Anouk Mercier

and dissemination of vital information, they are gradually turning into drawing boards for staff to decorate and embellish with their own drawings during tea breaks. They have become a site for in-house jokes, and short practical messages. They have become evocative mementos for the enduring relevance and necessity of drawing and mark making in the hospital environment.

Anouk Mercier's Residency was generously funded by the Tavolozza Foundation

7 THE FORCE THAT FUSES
DAVID FERRY

'THE FORCE THAT THROUGH THE GREEN FUSE DRIVES THE FLOWER'[1] Dylan Thomas, 1934

As humans, we have the privilege of looking at, and making art. It is a part of our humanity, an essential energy which drives us; and much like the energy found in nature, it is a force sometimes strong and sometimes delicate.

We often think of art as belonging in a museum or art gallery, but it is also present in many other places of human gathering. When I left art school, a hospital bought a set of my mono-prints. I had made these prints while on holiday in Crete, a personal response to the lovely warm sunny weather and the archaeological delights to be found there. The prints were bought specifically for a new scanning unit. I gave little thought at that time to what the scanner was or what it did; my world then revolved around making art and driving forward in the world with the 'force' that my art school education had given me. It took nearly forty years for me to understand just what these remarkable machines do and, more importantly, how they help patients.

In 2014, I was admitted to hospital following a serious road traffic accident. Over many weeks following my accident my hospital rehabilitation included a major operation, morphine, someone else's blood, x-rays, ultrasound scans, and many personal challenges. My intense discomfort was balanced by the art on the hospital walls, and the hospital allowed itself to be a place of imagination.

What follows is an autobiographical journey through a significant and life-changing period in my life. I have striven to create as authentic an account as possible, but I am also aware that my cognitive functions were a little impaired due to a heady mixture of serious trauma and morphine!

AUGUST 2014, BANK HOLIDAY: SOMEWHERE IN THE KENT COUNTRYSIDE. 9 A.M.

As I had done from the age of fourteen, and particularly on Sunday mornings, I prepared to go on a cycle ride. As usual, all seemed well, as it had on similar occasions for decades. For me, cycling is an essential companion to creating art, and the privilege of teaching it.

When cycling, I have a sense of liberation and a spirit of adventure – the same feelings artists have every time they go into the studio, and comparable to the pent-up excitement of getting back into the studio the morning after a big day's work, to spy the effort made. There really is something mesmeric about being on the road. On a bike, especially if resplendent in team or club colours, one assumes the status of an all-

conquering hero. There are no fears, speed is of the essence, and any other thoughts disappear; everyday life is rendered irrational, of no immediate consequence.

Cycling was my chosen sport, as art was my profession, and I won medals and competitions in amateur cycle racing in this country and abroad. The bike race – its cumulative build-up, its all-consuming relevance – was the pinnacle of this passion. As people, we develop abilities to balance desires and essentials, and then other urges; it is a delicate human manoeuvre of life choices. After I finished school, I wanted to be a cycle racer on 'the continent' (a term laced with expectation and the exotic). However, this was not to be and after a succession of pointless jobs, I joined the local technical college to study art at foundation level (pre-degree studies) and subsequently I went on to study in London, first at the Camberwell School of Arts and Crafts in South London and later as a postgraduate at the Slade in Central London. After graduation I was fortunate enough to earn a sustainable income through selling my artwork and from teaching part time.

Over the years, I became the head of department in a leading British art school and kept the 'Holy Trinity' of cycling, art and teaching in continual harmony, honed

1. James Green, Cartoon Image of David Ferry, sent as a get-well card, 2014, drawing and photomontage on card.
Photo: David Ferry

by years of practise. The week following the bank holiday ride, I was due to examine the exhibitions of a group of Masters of Fine Art students and celebrate the end of their period of study. I was then due a vacation and, not unsurprisingly, had booked a cycling and art break in the sun. Neither the examination nor the vacation ever happened.

Barely forty minutes after setting out on my ride, I was involved in a road traffic incident. A sheepdog ran into my bicycle's front wheel as I was descending a hill and I was catapulted across the road. Luckily there was another rider with me and other users on the road had mobile phones. An air ambulance was scrambled. Vaguely I saw it hovering overhead like a giant insect, quite unaware of the actual physical predicament I was in. Rational time and space give way to a self-sealing arena, and I was quite comfortable within it. I was later told this is a common reaction to powerful trauma, when chemicals in the brain flush through you and seal the reality of your actual situation. Following an initial roadside inspection by the emergency services, my Lycra kit was cut off. My prime concern at that moment was, 'Don't cut it off me – it's brand new!' It was soon deduced that there was a lot physically wrong with me, and I had started to shake very violently. I was given maximum pain relief and delivered at great speed to the nearest hospital.

WAKING UP, LOCAL HOSPITAL. 10.25 A.M.

These were very blurred and irrational times; I can barely remember anything. Waking up one random day, I was aware that I was neither at home in my studio nor at my favourite place in London, the Chelsea Arts Club. Instead I was surrounded by various orthopaedic contraptions and flashing light units which were attached to me. There was a constant toing and froing; it seemed like a circus all around me. I believe I slept a lot.

Some days later I was transferred to a specialist trauma hospital. I had, indeed, fractured many bones, including the pelvis, and sustained a serious head injury. After an operation to repair my pelvic region, which lasted about eight hours, I was placed in a high dependency unit, followed by a recovery ward for roughly six weeks.

The end of that August and early September period was a morphine-induced haze, but during this time, art, as I knew it, was starting to flicker back, prompted by the pictures and decorations that I spotted on the way to the x-ray and scanning units. I had come full circle to the island of Crete and those prints I had sold all those years ago. I became more aware of the people and the architecture around me. There was a lot of art around the place – it has a way of seeping into you in a way the medical apparatus never does.

I had my journal and sketchbook with me all the time in hospital and, as I gradually regained mobility and cognitive alignment, I began to draw (with my left hand as my dominant right hand was fractured), and was able to write down some observations and comings and goings of my 'teammates' on the ward. It is amazing, the comings and goings that take place, and sometimes at great speed. It is real life after all, not a condensed TV programme. Patients, visitors, doctors, consultants, anaesthetists, radiologists, porters, nurses, cleaners, counsellors, faith ministers – all are working and

thriving in this crucial environment. And art played a part in the healing setting, with its reflective sense of goodness, human kindness and care for others; it leaves a 'tattoo' in the mind, of something remembered and good. If the art is on the wall, it is also in your mind. It helps deal with the consequences of being yourself just when you need all the resources of goodness and medical expertise around you and adds significantly to a general spirit of wellbeing.

The recovery ward I was placed in had six beds, and each one has a little story to go with it. The following vignettes illustrate the remarkable and powerful facets of being in a hospital and some of the characters that the brilliant NHS staff care for.

2. David Ferry, fractured pelvis following an operation, 2014, photograph of screen. High Dependency Unit. Photo: David Ferry

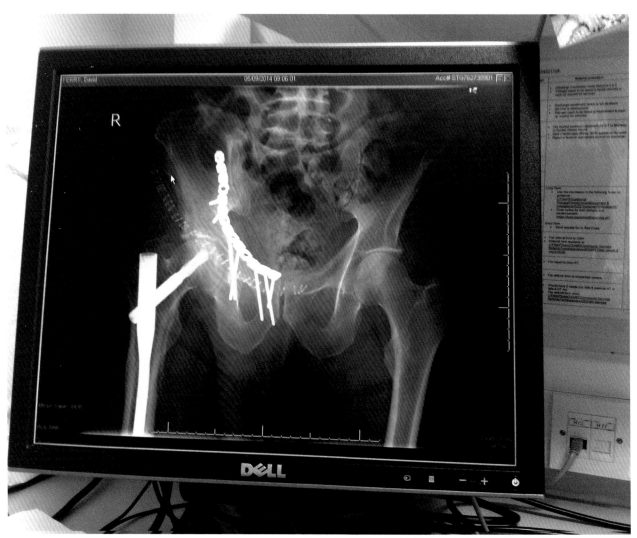

THE ARMED ROBBER

Late one night there was a commotion on the ward. A hospital trolley arrived accompanied by an emergency crew and the nurses – and also a troop of Metropolitan Police officers in uniform and plain clothes. The patient was cautioned and all our curtains were drawn around our beds.

It transpired that he was a burglar who had been armed. Over the next few days the chap entertained us with stories from 'the other side', using expressions which, at the time, I did not understand but wrote down in my notebook. There was a lot of rhyming slang, and plenty of very bad words.

3. Breakfast treats every morning; there was a similar cocktail in the evening, plus an injection, 2014. Photo: David Ferry

Abroad:
To my mind, this means a holiday overseas, but to him this was about being out and about, particularly at night, and usually up to no good.

Aggy:
I thought he meant aggression of some sort, but it alludes to 'aggravated burglary', the consequence of which was the reason he was in the hospital in the first place, having fallen off a roof trying to escape the police.

Bubble:
Short for 'bubble and squeak' – 'to inform'. He was concerned that he may have spoken in his sleep and the rest of us on the ward would inform the Police.

Iron:
Iron hoof , or 'poof ', and God help us if any of us in the ward, or a doctor or registrar, let alone the consultant, may have been one. I was reminded of a line from the film *Withnail & I*, when the character Uncle Monty, in a state of great passionate desire, likens the act of burglary to 'taking' the hapless character 'I'. Quite ironic that the chap in the bed was a burglar. I thought it best to keep this assessment to myself.

There were many such episodes with this character, and his 'right of centre' views. As the week progressed, we (the other five of us) began a conversation with him that activated the 'art' word, possibly because none of us wanted to engage with him on any other topic. To my amazement, after a litany of, swearing, sexism and racism, he came out with this delightful observation: 'Yea, mush, I like art an' that. You know, when I go down the x-ray, there's good pictures down there on the wall like, really clever.'

THE TAXI DRIVER
While on holiday abroad, this patient had a jet-ski accident that had left his legs in an unfortunate predicament, like doing the splits. He was transferred to the ward after an operation to realign them.

The taxi driver's great delight was watching adult movies at night, with the curtains drawn. Once, he forgot he was not wearing his headphones and the rest of us were treated to a running commentary on the developing scenario. Comedic and ludicrous, in a profound sort of way, it was a welcome antidote to the nightly sounds we had all had to endure and reluctantly accept. The performance was side-splitting, which was unfortunate given that I had fractured ribs and the other guys on the ward had similar, and worse, orthopaedic ailments, and tears of mirth were not really helpful.

One day he said to me, 'You know, Dave, I don't really know much about art, you being an artist and all that, but I saw a lovely picture downstairs. Reminded me of my holidays.'

'Not the splits!' I said.

'No, mate, that Mediterranean sun, proper "lurverly", all those yellows an' that.'

THE MINOTAUR

Things seem to happen at night in the hospital. Once, in the early morning, a rather theatrical thing happened. Three people were escorted to the bed very recently occupied by the taxi driver. I did not fully understand what happened next, but a very bronzed and heavily tattooed man sat on the end of my bed. His companions, resplendent in dominatrix gear and enormous stilettos, were both lying in his bed giggling. The nurse explained to them that the bed was actually for the man – who had been involved in an accident and needed to be there for the night prior to a specialist seeing him in the morning.

It turned out this was an adult entertainment group and during 'an act of performance' at a late night bingo club, the tattooed Adonis had fallen off the stage. He was a complete body sculpture, with bronze make-up and tattoos, little shorts, and what could well have been horns. I was immediately reminded of Picasso's *Minotaur*. I tried my best to capture this remarkable scene in my little book but it was too dark and I had had my medication for the night.

The next morning, before medication patrol, the Minotaur had risen from the sheets and was about to sign himself out. The ward was not the place of myth and legend and he had his next gig to get to; this clearly was not the natural setting for the brutal and passionate beast's next adventure. The lovely chap opposite me said how wonderful it would have been if the ward had the Vollard Suite6 of Picasso prints down the corridor. 'Did he say he was called, the Pillar of Hercules? Ha-ha, I didn't quite hear that.'

'No,' I responded. 'The gladiator, I thought?'

Unknown to all I had managed to take a candid photo in the morning, and during my later rehabilitation, I distorted the image slightly. As far as I was concerned he was the Minotaur.

THE KEBAB SHOP MAN

This patient was a lovely human being who had fallen down the stairs at the kebab shop he worked at, and had some similar injuries to my own. He used to watch me try to draw and would shout over asking me to hold up, in the best way I could, what I had tried to do. 'Can you give me a moustache?' he asked. I replied that my drawings were not really portraits, as such; that I was trying to get a sense of where I was and what to do with the time on the ward.

He had had a similar operation to me and was a little further down the line in the recovery stakes so he was able to make it onto the porter's chair to come over and see me. One time he said, 'You're good, you know. Perhaps one day you may have your pictures in the hospital. I like looking at the pictures in this place.' I am going home soon and will think of you, my friend, drawing in your bed.'

What a delightful and gentle man he was.

THE PROFESSOR

The sixth person in the ward was a lovely man who took great delight in challenging the 'armed robber' with a whole host of philosophical and cultural issues. These were delivered in a dry and authoritative tone that left the burglar tongue-tied.

I never knew bed number six's name but I called him the 'professor' as he was so splendid in his attitude to illness and his personal predicament. The taxi driver had his adult entertainment, the Minotaur his desire to escape to his next 'adult tableaux', the armed robber his bullying and arrogance, and the kebab shop man wanted to get back to his young children. I, sadly, had rather succumbed to being poorly, forcing myself to draw with my left hand, and then being disappointed with the results.

I never got to know the professor as he was constantly out of the ward receiving specialist treatments elsewhere in the hospital. He was there at night but by then most of us had had our last medication of the day and were ready for sleep. He asked me, one day, a most interesting philosophical question about art: 'Why have art?' I blathered something about how real it was in terms of things like creativity and necessity.

4. David Ferry (b. 1957), *The Minotaur*, 2014, manipulated photograph. Photo: David Ferry

5. David Ferry, evening meal, 2014, photograph.
Photo: David Ferry

'Not so,' he challenged. 'The real answer should be, morality itself is the key; it is there only to make aesthetic experience possible.'

My word, it was like going into a Masters seminar at the university, not the ward of an NHS hospital.

However, one important thing did occur to me: if the hospital exists to help us in physical need, then there has to be 'art' around the environment to give a sense of intrinsic human virtues, such as creativity and freedom. What a thoroughly wise and intelligent man the professor was. Of course there has to be art on the walls of the hospital, or anywhere, as we are able to appreciate and derive good from it.

ME, AND AN OBSESSION WITH MY HAIR
AND THE LAVATORY

After nearly a month in hospital I finally was able to get to a shower unit for help in washing my hair. I felt like a prince being wheeled back onto the ward in the porter's chair. All past thoughts of my comrades on the ward gone; I was clean again, and able to converse on a more confident level.

However, the other, and ultimately more delicate issue on my mind was that of going to the loo by myself. In my hospital journal (the captain's 'log', for *Star Trek* fans) I wrote about the whole scenario/adventure and have to admit, now, that I have to put my hand over my face when I read it back. To cut to the chase, I was given an enema, with specific emergency instructions that, once administered, I had to act quickly. After the enforced evacuation, I studied myself in the mirror: an incredulous look, disbelief and liberation in unison. I was wheeled triumphantly back to my bed, my comrades cheering my successful mission, like a hero in a military parade.

The hospital sanitary cleaning specialists were called. From the camouflage of my

6. David Ferry, drawing over found photograph of orthopaedic equipment that would be taken to David's home following discharge from hospital, 2014.
Photo: David Ferry

7. David Ferry,
'Collage Workshop'
initially begun in hospital on the
dinner tray, 2014.
Photo: David Ferry

bed, I claimed no knowledge of, and wouldn't admit to, the situation I had left behind in the ward's lavatory.

THE ALL-EMPOWERING ARTS

With this all-redeeming, two-part fresh start, I began to make a simple photo collage on my hospital table. It soon began to look like a cacophony of images and texts, and slowly started to reveal a new image altogether. There is a wonderful and unexpected equation that happens when you put two opposing visual elements together. In hospital, I was aware I could not do things that I normally did. Walking was one activity taken from me, and also cooking. While walking in extreme conditions like mountains and rough tracks and fine food dining were impossible, I could put them together with the aid of scissors and glue.

Some time later I made these 'hospital montages' into larger prints. Here lies a remarkable association with that poem of Dylan Thomas that begins this essay, about the force that drives us, and the delicate line we tread between loveliness and more awful things.

Two years after the accident I began to feel more enlivened, and I was elected the new chairman of the Chelsea Arts Club. Then Vice-chair (and now Chair) of the Club, Ginger Gibbons, initiated the first exhibition of Chelsea Arts Club artists at Chelsea

BEN LUI FROM CONNINISH

and Westminster Hospital in 2017. My image of cakes and mountains was back where it had begun, in a hospital. Our two exhibition spaces receive new artworks from club members every six months, to refresh the walls of the hospital and surprise staff and regular visitors with a selection of extraordinary variety. It is a partnership we delight in, to share our love of art with more daily visitors than many museums.

8. David Ferry,
Ben Lui, 2016,
digital archive print from an original photomontage.
Photo: David Ferry

9. Chelsea Arts Club members'
exhibition, 2017,
Chelsea and Westminster Hospital.
Photo: David Ferry

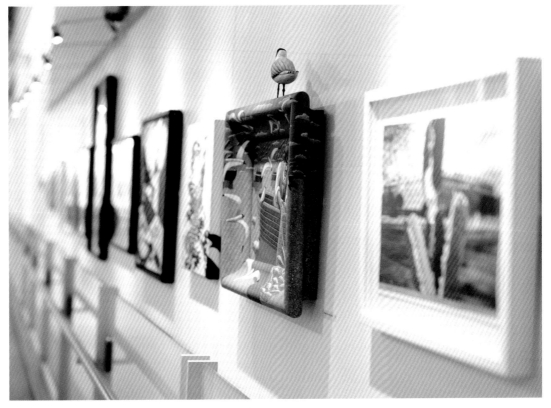

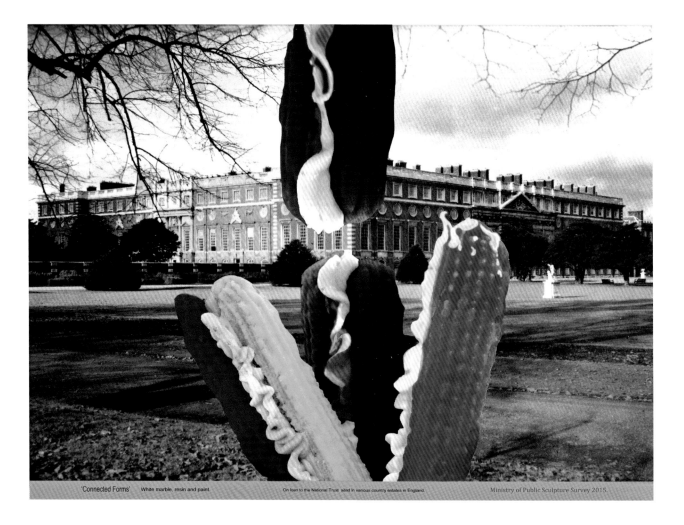

'Connected Forms' White marble, resin and paint. On loan to the National Trust sited in various country estates in England. Ministry of Public Sculpture Survey 2015.

10. David Ferry,
Connected Forms, 2016,
digital archive print on paper, with
stencil overlays, varnish and glitter.
Photo: David Ferry

Art in hospitals is an all-enriching and empowering force that drives goodness and culture through the darker channels of illness, grief and anxiety. Art is a constant force working in unison with all those remarkable technological innovations and talented and committed people that are at the heart of that most human of healing environments, the hospital.

8 THE HEALING POWER OF ART
GRACE SAULL

The CW+ arts programme thrives today thanks to the legacy of James Scott and his colleagues. They commissioned monumental sculptures for the new building's light and air-filled atria, brought music, performance and creativity into the day-to-day life of the hospital, and built the world-class collection of modern British art we hold today. When Allen Jones's *Acrobat* was installed in the hospital's foundations, art was both literally and conceptually embedded in the fabric of the building – an indication of the central role that art and design would contribute to the life of Chelsea and Westminster Hospital, now one of the most ambitious, creative and innovative 'arts in health' leaders in the world.

Twenty-six years on, CW+ has a collection of more than 2,000 artworks, including paintings, prints, photographs, drawings, sculptures and digital art, as well as major site-specific installations as daring as Allen's *Acrobat* was in 1993. Joy Gerrard's 2011 installation *Assembly/450* consists of 450 polished stainless-steel spheres and

rods forming clusters on five walls and traversing 30 metres of space. The sculpture highlights the unique architecture of the hospital, drawing our view around the bright atrium, and across the huge walls on which Gerrard's steel objects are scattered, and seem to have gently come to rest. As we ascend or descend the floors of the building, the objects reappear, presenting themselves anew with each viewpoint. How many visitors to a hospital expect to be greeted with art at all, let alone an installation of such bold scale and execution? There are only a handful of art galleries in the UK that could house an artwork of this size. *Assembly/450* changes the way we see the

1 & 2. Joy Gerrard (b. 1971),
Assembly/450, 2011, polished
stainless steel.
The Atrium,
Chelsea and Westminster Hospital

149

hospital's architecture as its hundreds of surfaces reflect its surroundings and the people in it, distorting and reconfiguring them. The artwork presents our environment and ourselves back to us in a subtly new form. Like the best art, it makes us stop and pause. Most importantly, it has the power to alter our perception of the building we have entered: one we may have assumed to be stark and clinical, yet we discover to be filled with surprises.

Our latest project of this ambitious scale is with Adam Nathaniel Furman, who has created a series of huge ceramic installations throughout our maternity department. The bold design takes its inspiration from springtime flowers, and uses colour, pattern and a modern waterjet cutting technique to make a big statement. (Figs. 14a & b). Although logistically challenging, our hospital colleagues understand the high impact that daring, large-scale art has on our patients, visitors and staff, and are willing to accommodate the extensive efforts required to make it happen. Without the culture of the arts that we have developed and fostered, creating ambitious public art like this would not be possible.

Many of the large-scale artworks displayed throughout Chelsea and Westminster Hospital function as landmarks, helping to orientate patients and visitors as they navigate walkways and entrances. Our collection, which tends towards bold, abstract work, often rendered in bright colours, offers memorable images, shapes and patterns that act as placemakers, creating strong visual identities in different areas of the hospital.

Chelsea and Westminster Hospital is a public building, open twenty-four hours a day. While most people who enter the hospital are doing so out of necessity rather than choice, in principle, anyone can wander in and look at the art. But a lot of people who come to hospital may not normally choose to go and seek out art by visiting museums or galleries. They may think that art is not for them. We have an opportunity to challenge that perception – commissioning quality works from emerging and established artists, working with groups like the Chelsea Arts Club to bring new and fresh art into the hospital, and displaying some fantastic modern art pieces which wouldn't be amiss on the walls of the Tate.

However, the hospital is not an art gallery or a museum and, while we of course look after the work we own, our collection is to be used rather than preserved. Compromise is necessary, and there is a fine balance between taking care of a collection and treating it as a living one, that is there primarily for the benefit of our community. Our art collection offers a positive distraction, uplifting colours, intriguing patterns, thought-provoking images, and the opportunity to be – however briefly – transported elsewhere.

A lot of waiting happens in hospitals, and with it comes boredom, fear and stress. Calming imagery and music have been shown to reduce the anxiety of those in waiting areas. They decrease pulse rate, respiratory rate, metabolic rate, oxygen consumption and blood pressure, as well as reducing stress hormones such as cortisol and adrenaline, and instead increase immune response (Roosmalen, 2010, Fancourt *et al.*, 2014).

Each year more than 135,000 patients arrive at our emergency department waiting room, often anxious, sometimes in pain, and in some cases highly distressed.

3. Still from RELAX Digital
Accademia,
Moving image artwork, 2018
Chelsea and Westminster Hospital

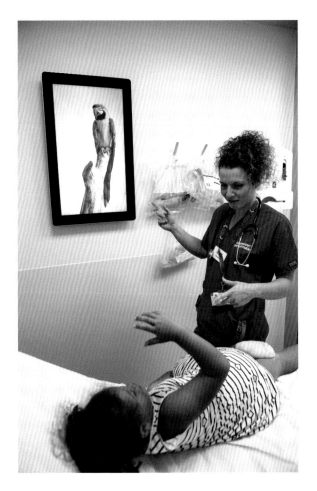

4. Accademia,
The Zoo, 2016,
digital artwork.
Chelsea and Westminster Hospital.
Photo: Ben Langdon/CW+

Typically, waiting areas can feel functional, unloved and uncomfortable, but there are scalable and innovative ways to change that.

RELAX Digital is a wider project by CW+ under which a number of initiatives are being delivered across Chelsea and Westminster Hospital. Flat digital screens in waiting areas and treatment rooms show high-quality commissioned moving content intended to relax and distract patients. Detailed, photographic-like images reveal themselves to be high resolution films that draw in the watcher and offer a meditative experience. In one scene, a street performer in Palma, Majorca, wafts a giant bubble maker, creating glistening pools of liquid light that drift across the screen. In others, pelicans slowly waddle in front of a fountain in St James's Park; boats bob and gently keel in a harbour touched by the warm glow of dusk; families stroll around a landscaped park on a sunny day. The scenes are quiet and unhurried. Even central London feels more relaxed. A panorama across the Thames shows the city under a dramatic, otherworldly sky, the wide, elevated view quietening the familiar bustle of the streets, the buses meandering down the riverfront. These films are installed in our emergency department, and throughout other waiting and treatment areas in the hospital. Unlike some projects, digital installations require limited space and upkeep. In areas where patients may be waiting for a long time, the moving and changing content

5. Tomato the Pacific Parrotlet Still from Accademia, *The Zoo*, 2016, digital artwork. Chelsea and Westminster Hospital

maintains interest in the artwork. The content can be varied and tailored to different requirements, patients can be provided with choice, and content can be changed depending on the patient group, or the function of the space.

Our most successful digital project to date is *The Zoo*, commissioned in 2016 and developed with creative filmmakers Accademia. It is a ninety-minute, award-winning film which consists of up-close, moving portraits of animals ranging from domestic to wild, tiny to enormous. Filmed in partnership with Battersea Park Children's Zoo, Battersea Dogs and Cats Home, London Aquarium, Colchester Zoo and Hounslow Urban Farm, *The Zoo* is designed to distract, engage and calm children while they wait for and receive care in the children's emergency department. It was developed with staff and patients, and is shown on 32-in [81-cm] portrait screens designed to play continuously – and they do. Alongside a leaflet of

fun facts about the animals (my favourite of which is 'Tomato the Pacific Parrotlet'), the intervention aims to improve outcomes and provide a positive experience for our young patients and their families. The use of distraction during the treatment of young patients is widely accepted as effective in reducing perceived pain and distress, and after a pilot study of *The Zoo*, 84 per cent of clinicians reported improvement in their patient's anxiety and 79 per cent reported improvement in their patient's perceived pain. A full clinical trial looking into the effectiveness of *The Zoo* is currently underway, and it has already been installed in the children's outpatients department due to its popularity with staff.

Installing art in hospitals is far from straightforward. Considerations, including hygiene and infection control, ease of cleaning and maintenance, and of course budgets and physical space, are as important as the content of the art itself. Digital technologies can provide us with new ways to integrate the arts into highly clinical, complicated or compact spaces.

They also enable us to provide access to natural imagery, which has been shown to improve healthcare outcomes in several studies (Ulrich 1984, Biederman and Vessel 2006).

Biophilia, or access to nature, forms a part of our commitment to creating holistic design. We have worked hard to create areas that include calming environmental design, with careful attention given to lighting, colour, acoustics, furniture and clear information, alongside art. CW+ Greenhaven, an indoor garden created with renowned landscape designer and former psychologist and psychotherapist Jinny Blom, provides space for staff to take a break, gives patients a target to work towards with their physiotherapists, and gives families space away from the wards. It is a pocket of sanctuary, calm and connection to the world outside the hospital when we can't step outside.

6. CW+ and Jinny Blom (b. 1962), *Greenhaven*, 2016, indoor garden with printed containers. Chelsea and Westminster Hospital. Photo: Owen Richards

7. Photo: Charlie Hopkinson

8a & b. Monika Bravo (b. 1964),
Without Stones There Is No Arch,
2016, 250 x 150 cm, vinyl installation.
Chelsea and Westminster Hospital

At Chelsea and Westminster Hospital we are in a privileged position of being able to work with both emerging and well-established artists, many of whom will be making art for a healthcare setting for the first time. Being commissioned to create art in this context presents a challenge to an artist at any stage of their career. The unusual briefs that we give, far from being restraining, can be a gift for creativity, pushing artists in new directions.

In 2016 we commissioned interdisciplinary artist Monika Bravo to create a scheme of new work for our urgent-care centre. In this context, Bravo had to consider new challenges presented by the environment – factors such as photographic images needing to be either completely sharp or blurred to abstraction. Any mid-way point could cause confusion or distress for patients suffering from head injury or nausea. Using a palette of bright and uplifting colours, Bravo created a digital collage consisting of vertical strips that depict images of nature alongside instantly recognisable London landmarks. Bravo said of the commission: '*A city is a vessel and container not only of buildings and bridges, but of human experience; it is in the way we perceive the space and time that we form our memories.*' The title of Bravo's design, *Without Stones There Is No Arch*, refers to writer Italo Calvino's book *Invisible Cities*, in which Marco Polo describes a bridge stone by stone, emphasising that it is no single stone that supports a bridge, but 'the line the arch forms'; just as every member of staff in a hospital contributes to the care of patients, and no one person can do their job without the support of others.

Staff and patients are always consulted when a new artwork is proposed, and the artists we work with know that they will receive feedback on their designs and proposals from patient groups and clinicians. Not only do clinical staff understand the unique setting of their area of practice, but the art is also for them: to make their working environment more pleasant, enhance their wellbeing, increase their pride and investment in the service they provide. Staff support our research by telling us what patients need and provide feed back on how effective an artwork is once it is installed. It allows us fascinating insight into the way a certain medical service operates, what challenges they face, and how we can conjure creative solutions to support them in the care they provide – from distracting patients, to creating a calm environment, to using

9. Marthe Armitage (b. 1930),
wallpaper designs, 2017,
vinyl installation, detail.
West Middlesex University Hospital.
Photo: Owen Richards

10. Marthe Armitage, wallpaper designs, 2017, vinyl installation.
Photo: Owen Richards

good design to make a challenging space safe for its users.

Our clinical colleagues allow us to commission experimental work, which we develop alongside outcomes-based research, and which enables us to invite artists into the hospital to observe, respond, experiment, play and take risks. Artists are given the opportunity to think laterally, and suggest new, creative ways of seeing and understanding our acute care environment. Such openness of approach also risks failure. Rather than being at odds with clinical approaches, this quality is complementary, and certainly crucial to any creative endeavour. All creative practice risks failure, as does medical intervention, and it is through such risks that discoveries are made, progress is possible and ultimately, lives are changed. The unique culture of support in the arts is undoubtedly the reason these risks invariably pay off.

A year ago, CW+ began working with our our sister hospital site in Hounslow, West Middlesex University Hospital, which had never previously had an embedded arts programme. We were excited by the chance to share the experience gained from our work at Chelsea and Westminster Hospital, and to apply it to a new site and community of people. For the first commission at West Middlesex University Hospital, we approached internationally renowned wallpaper designer Marthe Armitage, who lives locally to the hospital and works from a studio in Chiswick. Armitage is known for her hand-printed wallpapers, produced using the traditional technique of block

printing. Working towards installations in our cardiac catheter laboratory and older patients wards, she adapted her intricate designs to be printed onto vinyl, a material suitable for the hospital environment.

Armitage generously allowed us to play with the scale and colours of her existing designs to create wall treatments that would be most impactful in these units, based on our experience and research, and the advice of clinical staff. Installing new artwork involves building relationships of trust: between the artist and CW+, and with staff and patients. Working with Armitage as a local resident had the additional advantage as a way of reaching out to nearby communities.

Armitage has been designing hand-printed wallpapers for over fifty years and her detailed designs are inspired by the natural world. Patients in the cardiac unit are often waiting to have heart tests, which understandably can be a worrying time, so the aim was to install art that would remove the highly clinical feel of the environment and create a simulated domestic space.

Now in her eighties, Armitage continues to be as creative and innovative as ever, but this was her first experience of making work for a healthcare setting. She said: '*I was very pleased to be asked to be involved in this project. I have not worked in a hospital before, so it's lovely to see my designs in a new and different environment. I hope my wallpaper will help to calm patients by giving them something to really look at. I find if you really look at something, it can help take your mind off yourself – which I hope will help these patients feel a bit more relaxed.*'

The wallpapers have transformed the spaces, with many patients and visitors commenting on how beautiful they are. The success of this commission speaks for itself: CW+ has been inundated with requests for artworks from clinicians at West Middlesex and we now have a waiting list for commissioning new works.

While the design and workings of an acute hospital setting will always necessarily prioritise clinical need and practicality, we want to use art and design for function not just decorative effect, and there is increasing recognition of this pioneering approach with such thinking now becoming mainstream. For instance, it is now standard practice in healthcare building projects to consider the psychosocial context of the healthcare environment (All-Party Parliamentary Group, 2017, p.66), while clinicians increasingly recognise the benefits of art and design in helping people to stay well, recover more quickly, manage long-term conditions and experience a better quality of life.

In hospital we are often at our most vulnerable, and are reminded of our human frailty. Art in hospitals reminds us of our incredible power to imagine and create, and connects us to others in the most fundamental human way. Through seeing and experiencing art and taking part in participatory arts programmes in the hospital, our hope is that when patients and visitors leave, they will be more likely to engage in creative and cultural activities in the future. Those who attend cultural venues and events have been found to experience less work-related stress, and lead longer, happier lives. Statistics around arts engagement offer clear and unequivocally positive evidence: after engaging with the arts, 79 per cent of people in deprived communities in London ate more healthily; 77 per cent engaged in more physical activity; and 82 per cent enjoyed greater wellbeing (All-Party Parliamentary Group, 2017, p.9).

11. Lauren Baker (b. 1982).
Galaxy Explosion Yellow, 2019.
Print with hand embellished
diamond dust.
Chelsea and Westminster Hospital.

At CW+, we are proud to be leaders in the arts and health field and grateful to be able to continue to innovate. Ultimately, it is crucial that we can share our work and show best practice. We have been evidencing the impact of arts in health since the early stages of our arts programme. Between 1999 and 2002, CW+ undertook the first UK study to explore the clinical impact of visual arts and live music on the health outcomes of our patients: Staricoff's 2004 *Study of the Effects of Visual and Performing Arts in Healthcare*. We continue to research the impact of our programme, working with partners that include Imperial College London and the Royal College of Music.

While the effects of art and design on the body and mind are as varied and subjective as people themselves, there is overwhelming evidence that the environment a patient finds themselves in can have profound consequences for their healing. The growing raft of evidence that the arts can significantly contribute to addressing the issues faced by our health and social care systems is being taken increasingly seriously, as reflected by The All-Party Parliamentary Group on Arts, Health and Wellbeing Inquiry's substantial report, *Creative Health: The Arts for Health and Wellbeing*, published in 2017. The report references Chelsea and Westminster Hospital's work and evidences, across a wide-ranging scope, how arts-based approaches can keep us well and aid recovery; help meet the major challenges faced by health and social care services, including ageing, long-term conditions, loneliness and mental health; and save money for services.

'Arts on prescription' is an area of growth through which local authorities and central government see the potential for saving money and in which clinicians recognise positive clinical outcomes. 'Arts on referral' is a form of social prescribing, a process in which health and social care practitioners refer people to non-clinical services for a wide range of physical or psychological conditions, including chronic pain, stroke, depression and anxiety. A range of arts and creative activities might be prescribed, such as painting, drawing, ceramics, gardening, cooking, dance, drama, singing or poetry. These activities can be designed for people with particular health

conditions, such as singing for lung health, creative writing for post-partum support, and music for dementia, which support the specific needs of the group.

It is estimated that one in five visits to GPs is made for psychosocial reasons (All-Party Parliamentary Group, 2017, p.72), and as such, social prescribing aims to address the broader causes of ill health by looking for solutions in existing community settings as opposed to clinical environments. As primary care services come under increasing demand and financial pressure, social prescribing is becoming an NHS priority, with its focus on prevention, early intervention and managing long-term conditions in an ageing population. A 2015 report, *Social Prescribing: A Review of Community Referral Schemes*, found that common outcomes of referrals were: increased self-esteem and confidence; a greater sense of control and empowerment; improvements in psychological wellbeing; and reduced anxiety and depression (ibid).

In 2018, Matt Hancock MP, Secretary of State for Health and Social Care delivered a speech which has the potential to catapult arts in health into the mainstream. He said: 'For too long we've been fostering a culture that's popping pills and Prozac, when what we should be doing is more prevention and perspiration. Social prescribing can help us combat over-medicalising people. Of dishing out drugs when it isn't what's best for the patient. And it won't solve their problem. Social prescribing is a tool that doctors can use to help them, help patients and help the NHS cut waste.'[2] He calls for a state-sponsored National Academy for Social Prescribing, a massive shift in attitudes towards the arts and creative practices for health. It marks a general shift in the long-embedded thought that art is outside of life, and that it is separate to the everyday. It reminds us that art is not additional but a core need for our society, reclaiming art as a useful tool.

12. Fanny Shorter (b. 1983). *Calathea* 2019. Screen Print on Board. Chelsea and Westminster Hospital.

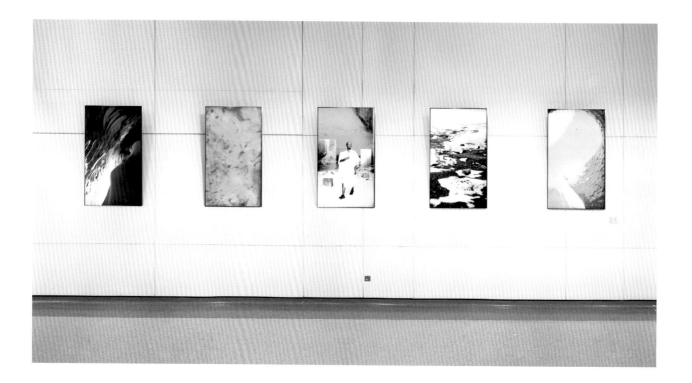

13. Isaac Julien.
Stones Against Diamonds
(Ice Cave), 2015.
5 portrait screens with HD playback.
58'28".
Courtesy of the artist and Victoria
Miro London/ Venice.
© Isaac Julien.
Photo: Max McClure.

An evaluation of *Artlift*, an arts on prescription scheme in Gloucestershire, found significant improvement in wellbeing and mood among people referred. It also found that GP consultation rates dropped by 37 per cent and hospital admissions by 27 per cent between the year preceding referral and the year after. Taking account of savings to the NHS against the cost of *Artlift* interventions, this represented a saving of £216 per patient (ibid, p.73).

Arts on prescription acknowledges the overwhelmingly positive effect that active participation in the arts can have on all of us and understands our health and wellbeing in a broad context. It recognises that our physical and mental health are intimately connected and that, to some extent, we all have the power to positively impact our own health.

As we have found at Chelsea and Westminster Hospital, bringing the arts into our acute hospital setting has similar effects in combating feelings of social isolation during long hospital stays and speeds up recovery times. Looking to the future, we want to support our patients and communities to continue to access creative activities for wellbeing in our community, both in and outside our walls.

The UK is known across the world for its art, music and culture. In July 2018, the NHS celebrated its seventieth birthday, and continues to be one of Britain's best loved institutions. It plays a vital role in our lives and is there to care for us every single day. Like the NHS, art has the power to support us, guide us and make us feel better. Art can show us new ways of looking at ourselves, others and the world around us. Both our culture and the NHS continue to achieve incredible things of which we

14a & b. Previous and this page.
Adam Nathaniel Furman (b.1982).
Radiance, 2019.
Ceramic Installation.
Chelsea and Westminster Hospital.
Photo: Gareth Gardner.

should be proud, but not complacent. Investment in the NHS and the arts is vital: they are life savers and enhancers, both crucial to living our lives well, healthily and happily.

Hospitals are never still. They are sites of constant activity, of continual movement and motion. Similarly, we continually seek to innovate with our programme, using new technologies, innovative ideas and by commissioning ambitious projects. There is something visual, musical, creative, performative or participatory for everyone. Over the next twenty-five years we will continue to engage our patients, their loved ones, and our staff, with as many diverse and creative opportunities as possible. We're excited to see what is going to come next.

ACKNOWLEDGEMENTS

CW+ is deeply grateful to the artists, partners, and donors who have contributed to this project. We have been humbled by the enthusiasm and support of everyone who has been a part of creating this book, and the programme it celebrates.

We would like to thank Philip Hoffman and the Fine Art Group for their ongoing support, and for their sponsorship of this book.

Thank you to each of the authors, all of whom have given us their time, thought, and reflections on their experiences - particularly James Scott, who initiated this project. Thanks also to Ellen Wilkinson and Greg Windle, who were both fundamental in the production of *The Healing Arts*.

Our work would not be possible without the generosity of our donors and supporters. A special thank you to our Art and Design Committee, led by Sarah Waller CBE, who provide invaluable guidance and advice which allows us to transform the environment and experience of our community; Nathan Askew, Tony Bourne, Fiona Costa, Juan Cruz, Kate Gordon, Jeremy Loyd, Sophie Oppenheimer, Liz Shanahan, Jane Suitor, and Andrea Weigert – and our expert panel; Virginia Ibbott, Nicholas White, Jordan Baseman, Gerry Farrell, Gemma Stewart Richardson and Jinny Blom. We are incredibly grateful to our donor community, many of whom have a personal connection to our hospitals, and whose support has enabled the programme to flourish and innovate.

We contacted many artists and estates during the creation of this book and would like to express our gratitude once more to those who gave us permission to reproduce their artwork and share so many fantastic pieces from our collection in print.
Thank you to Unicorn Publishing, who were so willing to support us in this project – particularly Lord Strathcarron, Chairman, and Lucy Duckworth, Production, for helping us shape the book; Louise Campbell for marketing, and Tim Epps for his tireless work on the design of each and every spread.

Finally, we would like to thank the patients, families, volunteers and staff who make up our community, who give us the space and trust to bring our programme into our hospitals, led by the CEO of Chelsea and Westminster NHS Foundation Trust, Lesley Watts.

IMAGE CREDITS

COVER IMAGE & INTRODUCTION

© Albert Irvin. Courtesy of the estate of the artist, Photograph by CW+.

PAGE 4
© Chloe Dewe Mathews.
Photograph courtesy of the artist.

CHAPTER 1
1 Creative commons, Photograph by Matt Brown; 2a Photograph courtesy of Kensington Central Library; 2b Photograph courtesy of Kensington Central Library; 3 ©Faye Carey. Photograph by CW+; 4 Photograph by CW+; 5 © Patrick Heron. Courtesy of the estate of the artist; 6 © Allen Jones. Photograph by CW+; 7a © Sian Tucker. Photograph by Owen Richards; 7b © Sian Tucker. Photograph by Owen Richards; 8 © Albert Irvin. Courtesy of the estate of the artist. Photograph by CW+; 9 © Maggi Hambling. Courtesy of the artist. Photograph by CW+; 10 © Richard Smith. *Seraphim* © Richard Smith Foundation. All Rights Reserved, DACS 2019. Photograph by CW+. 11 © Jonathan Delafield Cook. Courtesy of the artist. Photograph by CW+; 12 ©Virginia Powell. Photograph courtesy of the artist. 13 © Sandra Blow. Courtesy of the estate of the artist. Photo by CW+; 14 © Mary Fedden. Courtesy of the estate of the artist. Photography by CW+; 15 © Edward Bawden. Photograph courtesy of Jennings Fine Art and Liss Llewellyn; 16 © Kenneth Armitage. Photo by CW+; 17 © Edward Bawden. Photograph by CW+; 18 © Prunella Clough. Photograph by CW+; 19 © Nigel Hall. Photograph by Jonty Wilde/Yorkshire Sculpture Park; 20 © Eduardo Poalozzi. Courtesty of the artist. Photograph by CW+; 21 © Wendy Taylor. Photograph by CW+; 22 © William Pye.

Photograph by CW+; 23 © David Gaggini. Photograph by CW+; 24 © Barbara Hepworth. Photograph by Bowness/ DACS; 25 © Martin Creed. Digital image courtesy of artist; 26 © Howard Hodgkin. Photograph by CW+;

CHAPTER 2
1 © Eduardo Poalozzi. Photo by CW+; 2 John Hoyland. *Hating and Dreaming* © Estate of John Hoyland. All rights reserved, DACS 2019. Photo by CW+; 3 © Lucy Le Fevre. Photograph by CW+; 4 Photo by CW+; 5 © Julian Opie. Courtesy of the estate of the artist; 6 © Allen Jones. Photograph by CW+; 7 © Sean Scully. Courtesy of the artist. Photograph by CW+; 8a © Sandra Blow. Courtesy of the estate of the artist; 8b © Sandra Blow. Courtesy of the estate of the artist; 8c © Sandra Blow. Courtesy of the estate of the artist; 8d © Sandra Blow. Courtesy of the estate of the artist; 9a © Melvyn Chantrey. Photograph by CW+; 9b © Melvyn Chantrey. Photograph by Sam Roberts; 10 © Albert Irvin. Courtesy of the artist. Photograph by CW+; 11 © Edward Bawden. Photograph by Sam Roberts; 12 © Sian Tucker. Photograph by CW+; 13 © Joy Gerrard. Courtesy of the artist. Photograph by CW+; 14 © Photograph by Sam Roberts; 15 © Photograph by Sam Roberts; 16 © Patrick Heron. Courtesy of the estate of the artist; 17 © Gillian Ayres. Courtesy of the estate of the artist; 18 © Wilhemina Barns-Graham. Courtesy of The Wilhemina Barns-Graham Trust; 19 © Joe Tilson. *Geometry ?, 1965.* All Rights Reserved, DACS/Artimage 2019. Image: © National Galleries of Scotland DACS/Artimage 2018. London. 20 © Henry Moore. Photograph by The Henry Moore Foundation; 21 © Georges Braque. *The Birds*